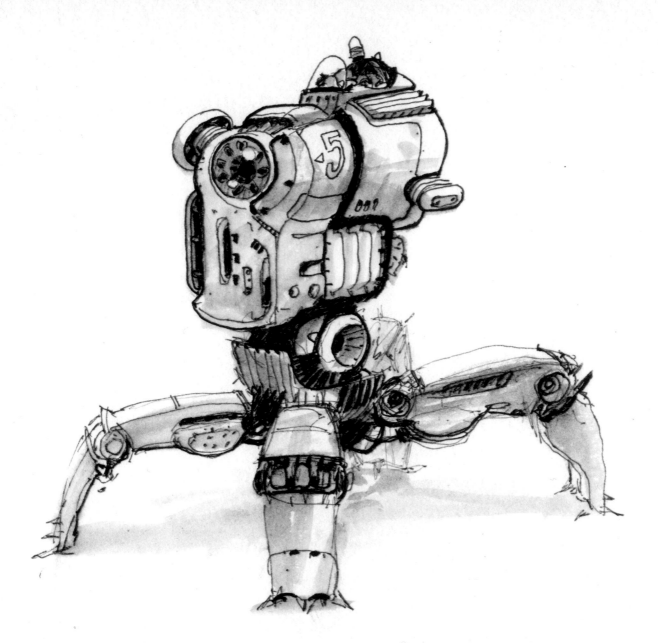

INKTOBER 1
Scott Robertson 2015

/// SKETCH COLLECTION VOL. 02:

SCOTT ROBERTSON

designstudio | PRESS

introduction

After the completion of my books **How To Draw** and **How To Render** at the end of 2014, I needed some time away from writing books, so over the last three years I've been devoting my skills to a start-up company as its chief creative officer. This has meant that I've not had the free time as before to support my YouTube channel, for instance, or to do much in the way of personal sketching and rendering. The one exception to this has been trying to rally each October to take part in Jake Parker's "Inktober," when lots of artists from all over the world work on their ink skills by trying to do an ink drawing a day during that month. Most of the sketches in this book were created during my 2015/16 Inktober exercises. There were two other bursts of productivity: at the beginning of 2016 until mid-February and then, most recently, this summer of 2017, as I saw that I had enough work to put together a little sketchbook for the holiday season. Having a little side project has been fun and has gotten me back into drawing, just in time for Inktober 2017! If you follow my Instagram feed @scoro5, then you will have seen most of the work in this book, albeit only in the tiny, poor-resolution Insta-form. Many of the sketches in this book are printed larger than the original size, and those of you who own the originals will be able to compare them. Almost all of the drawings were in an 8.5x11" sketchbook, so the majority of the originals are no wider than the width of this book. Each November for the last couple of years I have sold my original sketches in one eBay auction, should you ever want to pick up a unique gift for yourself or others. (Wink!) Thanks for the continued support of my previous books, YouTube channel, and my newer educational outlet, Gumroad. You can find all of my online resources and social-media streams listed at the back of this book.

Scott Robertson.

August 10, 2017
Los Angeles, California

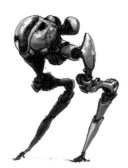

The making of some of the work in this book was recorded and can be found on my YouTube or Gumroad channel. These sketches, or series of sketches (in the case of the motorcycle design), are indicated throughout the book by the YT (YouTube) and GR (Gumroad) icons below.

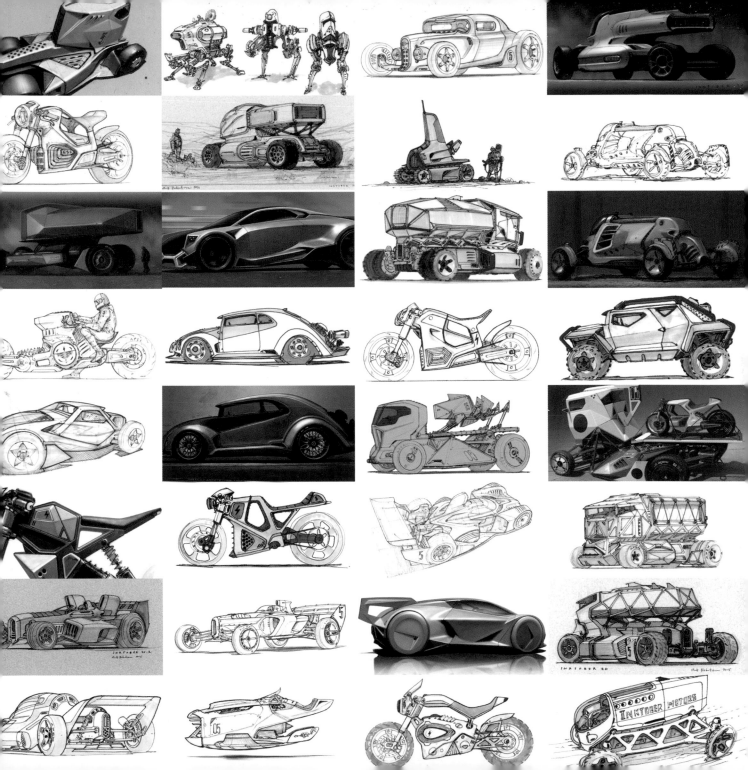

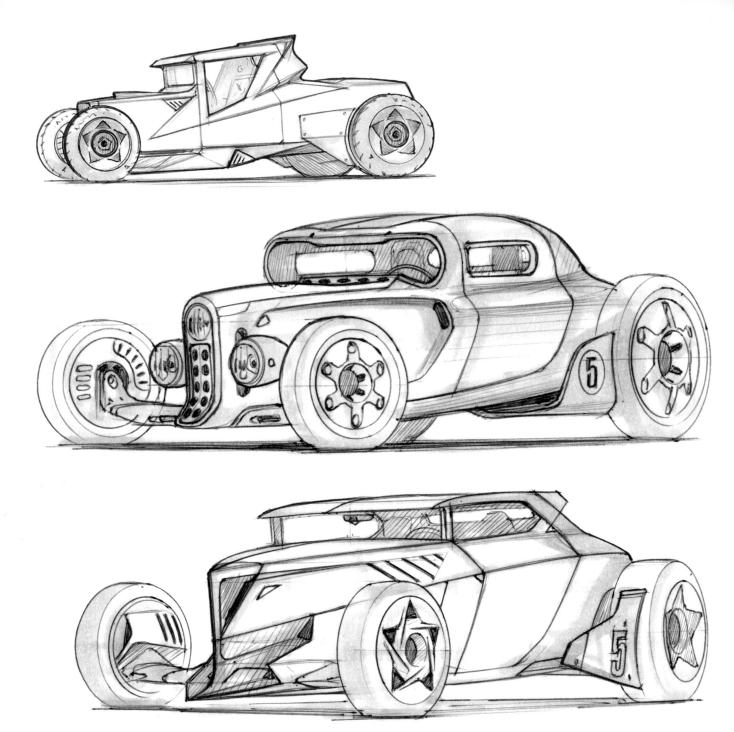

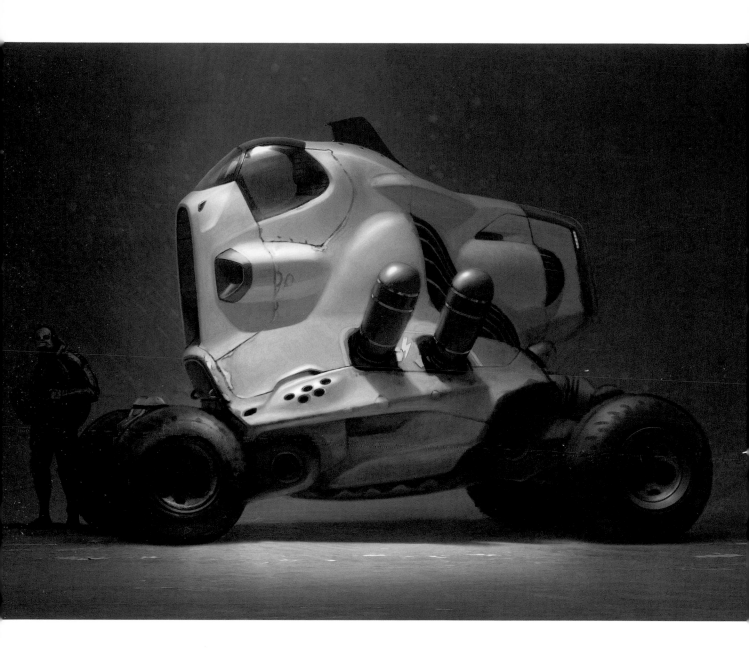

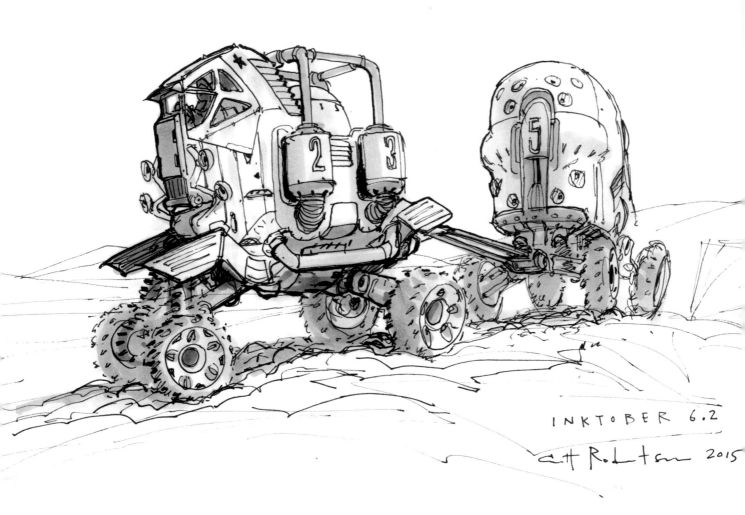

INKTOBER 6.2
Sctt Robtsn 2015

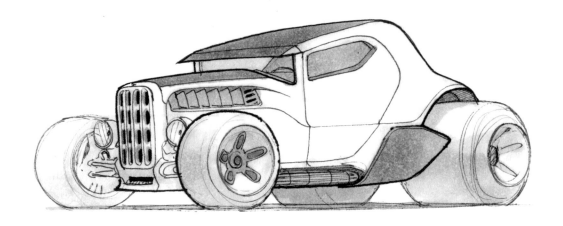

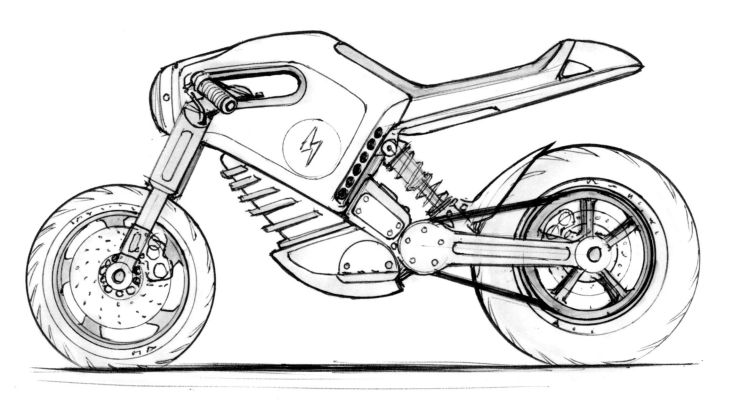

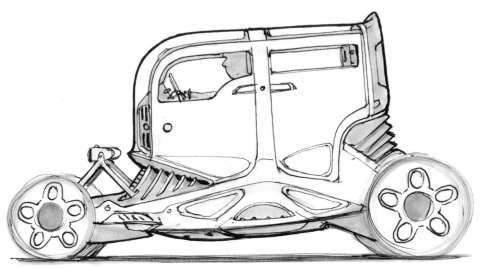

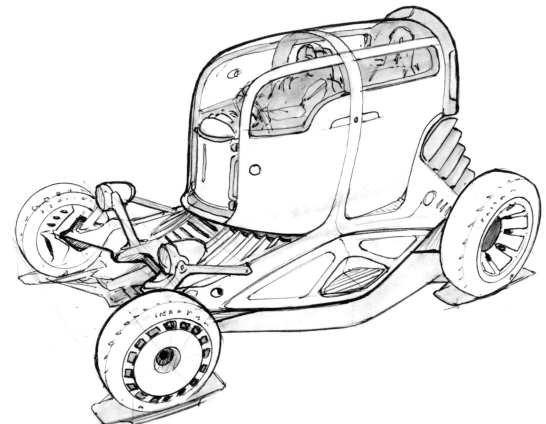

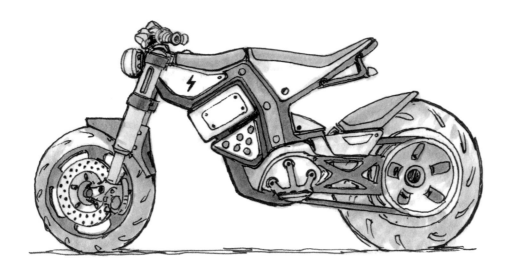

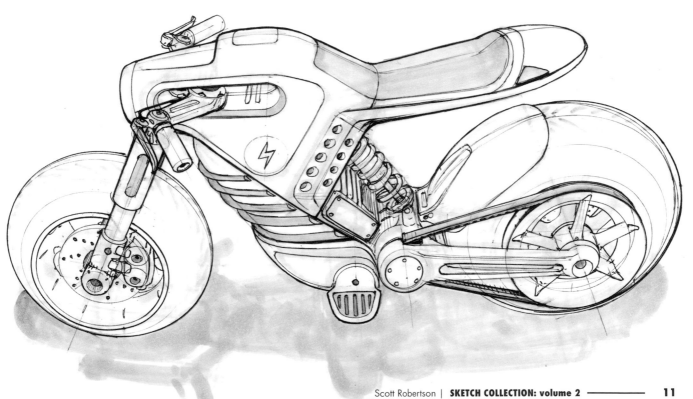

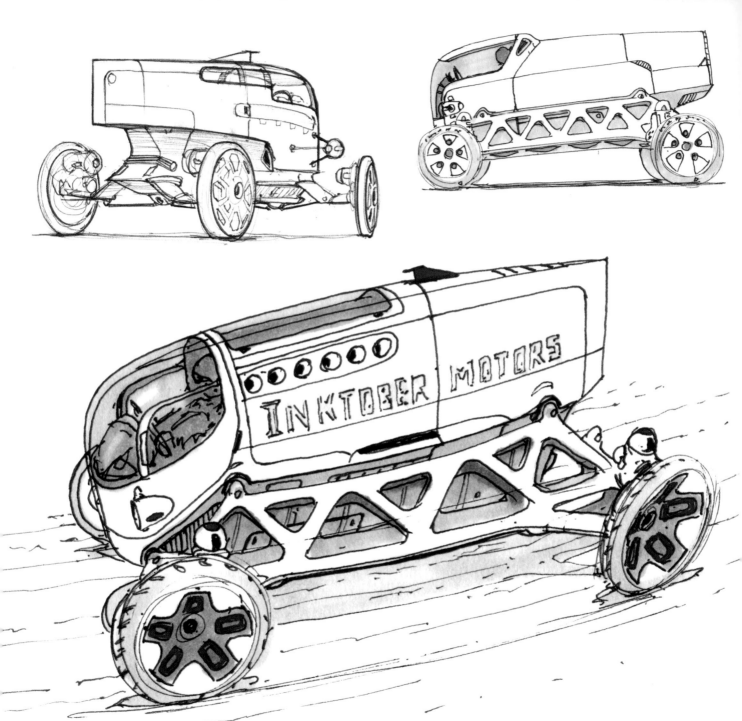

INKTOBER MOTORS

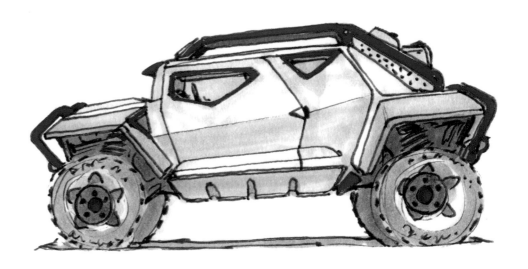

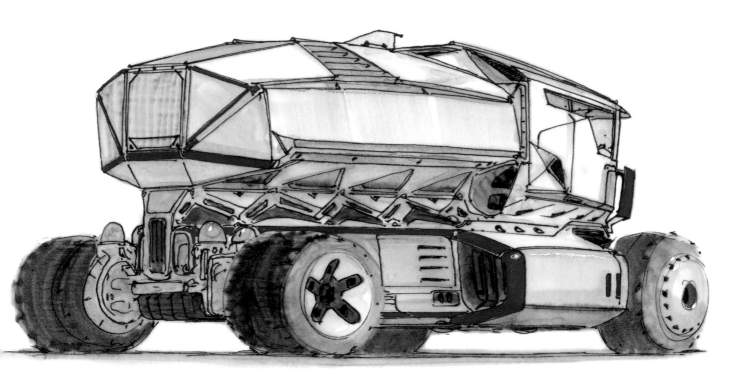

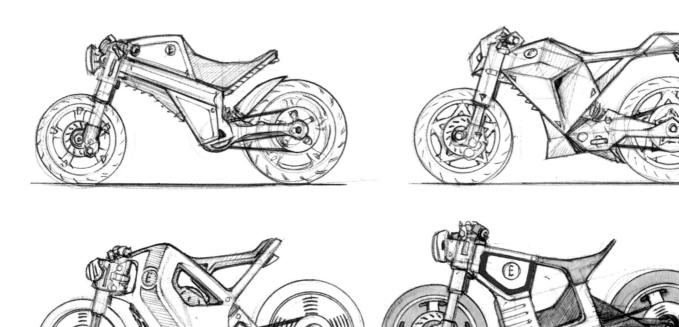

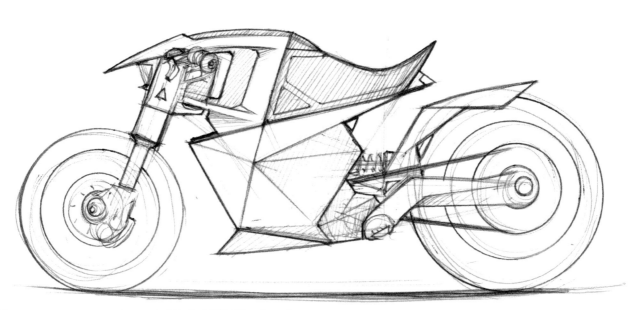

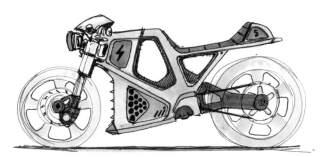

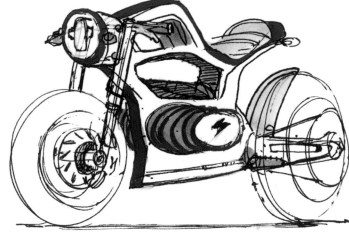

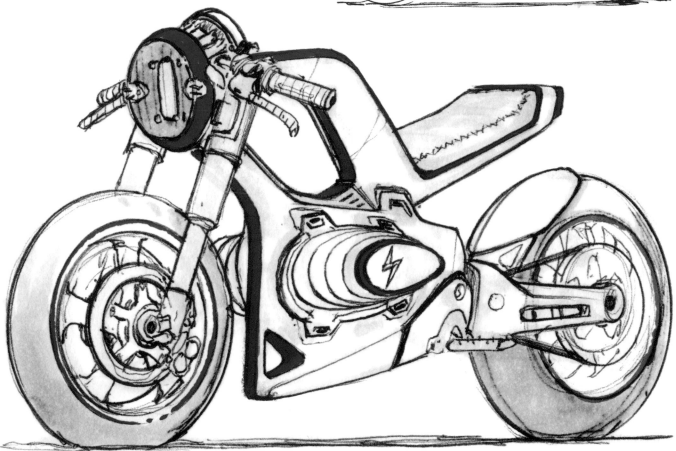

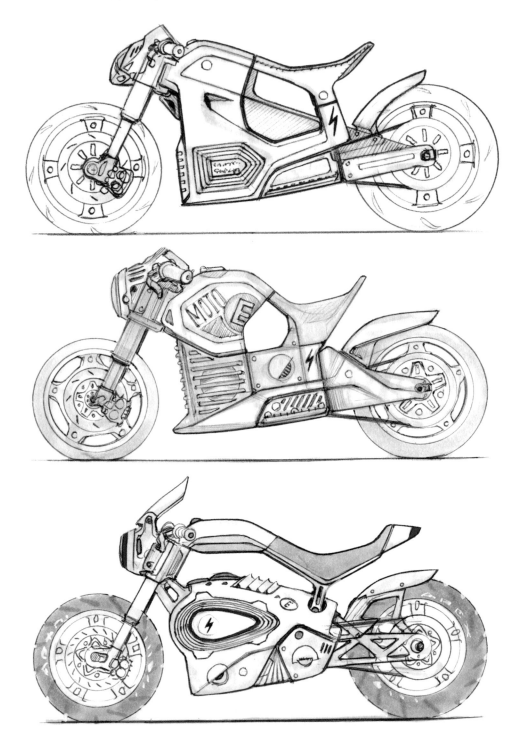

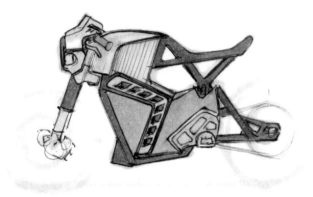

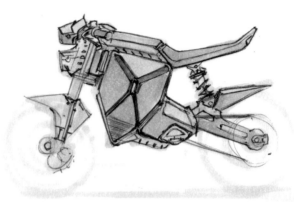

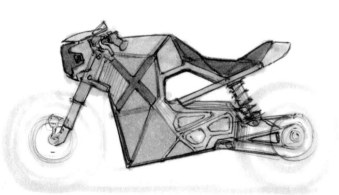

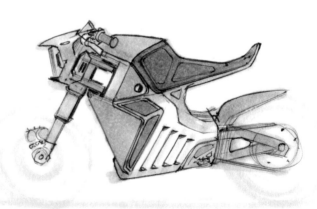

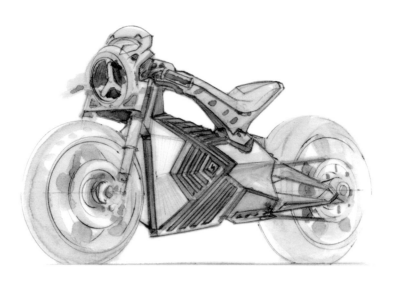

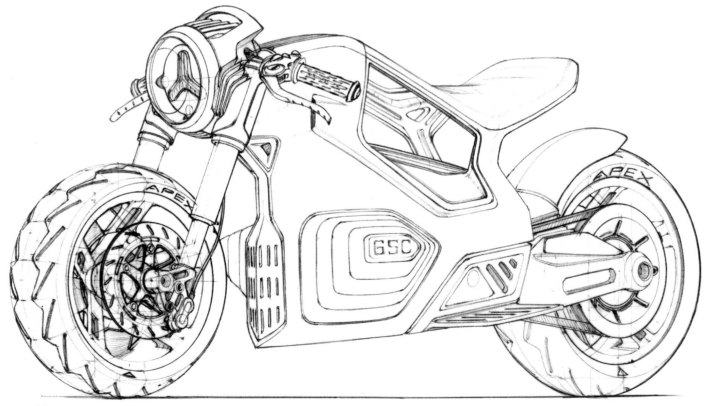

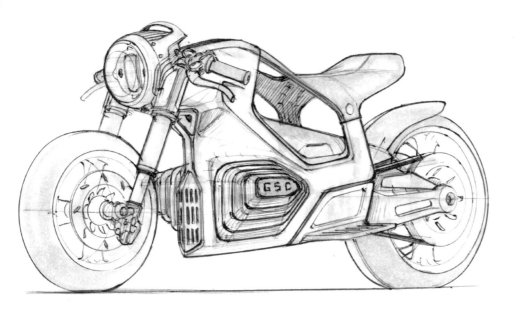

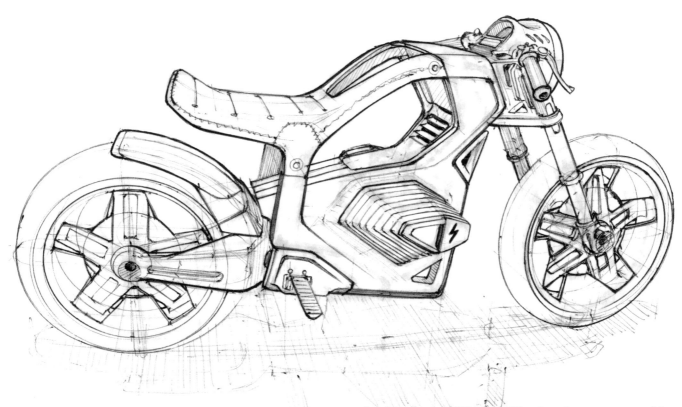

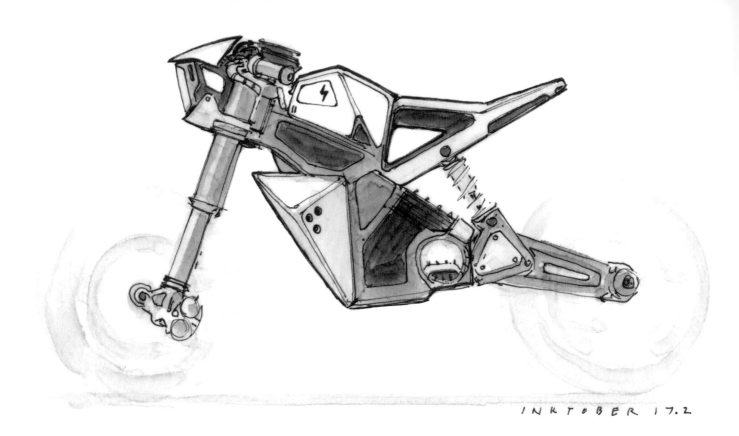

INKTOBER 17.2

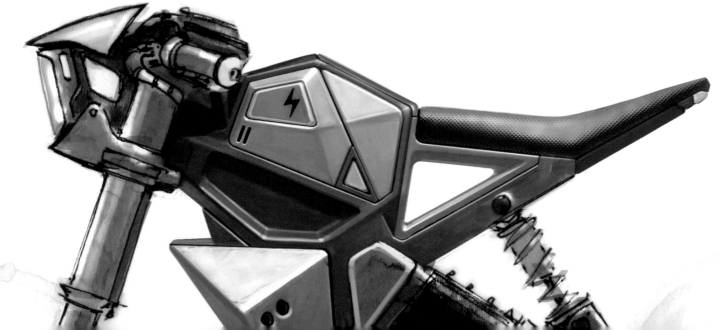

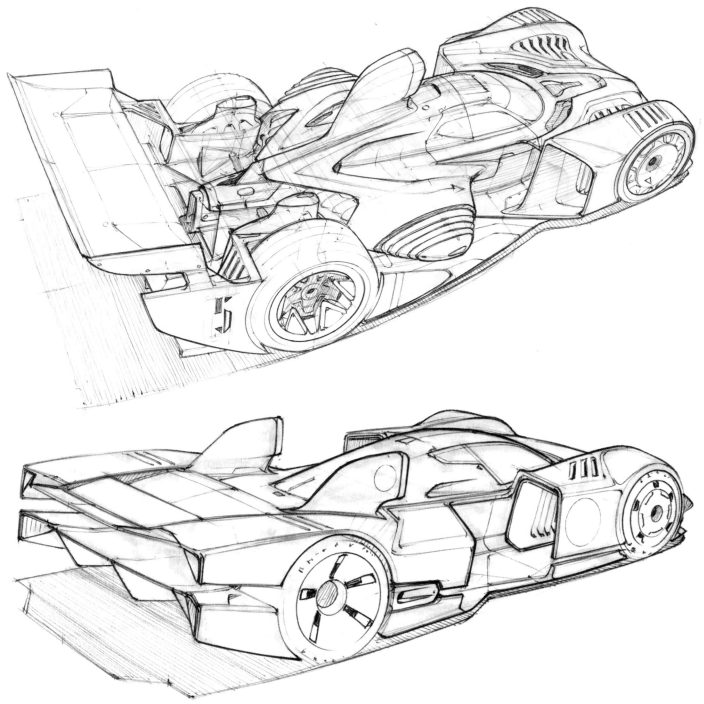

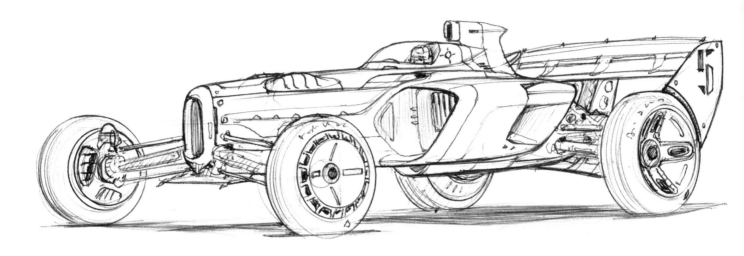

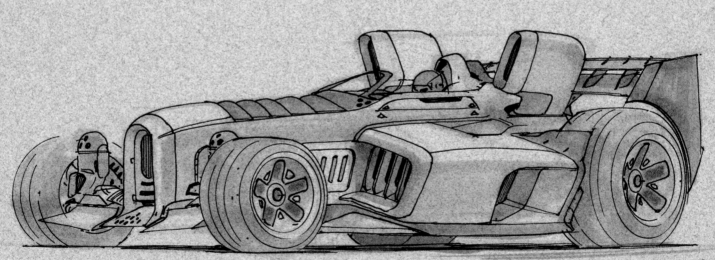

INKTOBER 20.2
CH Robertson 2015

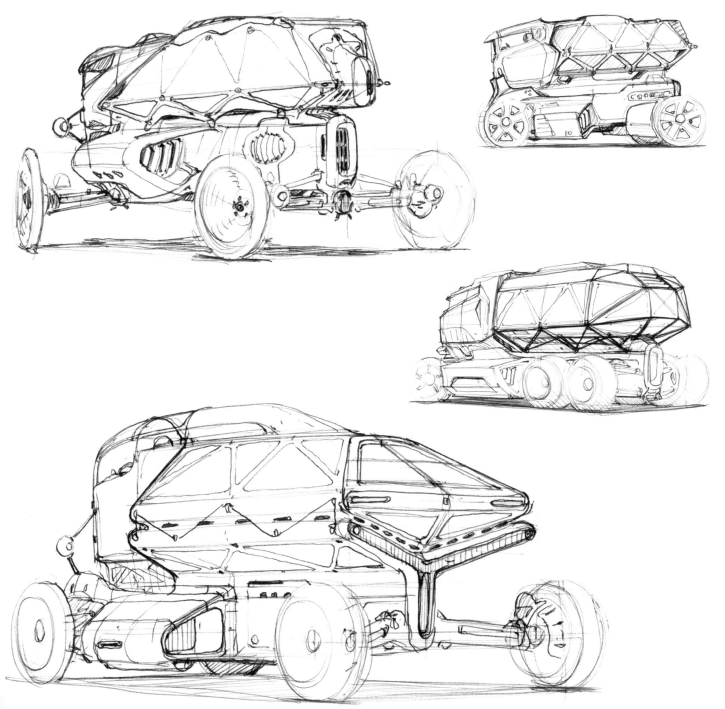

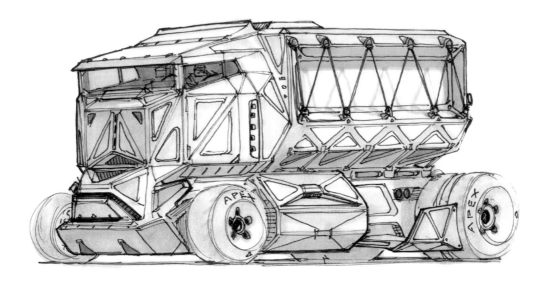

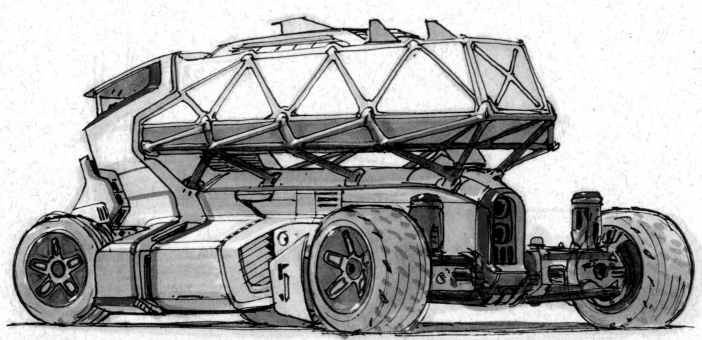

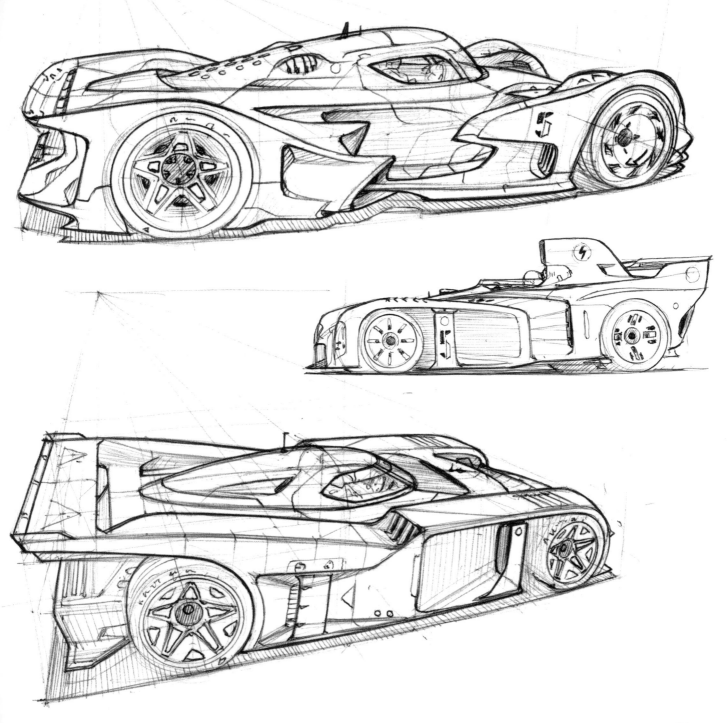

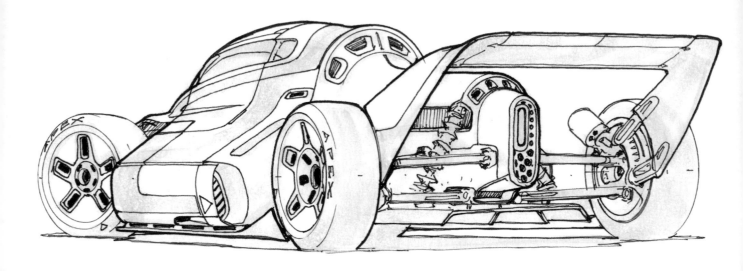

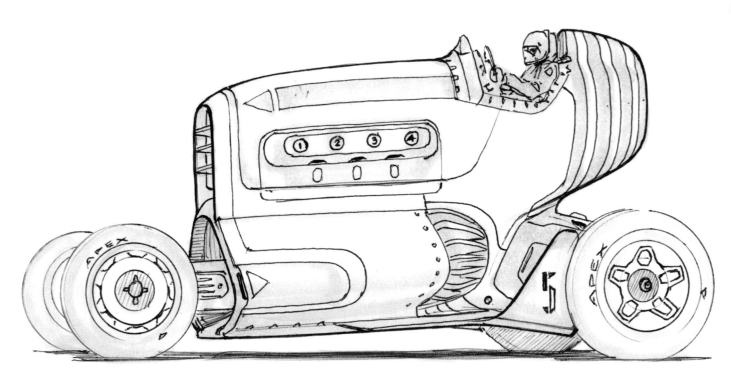

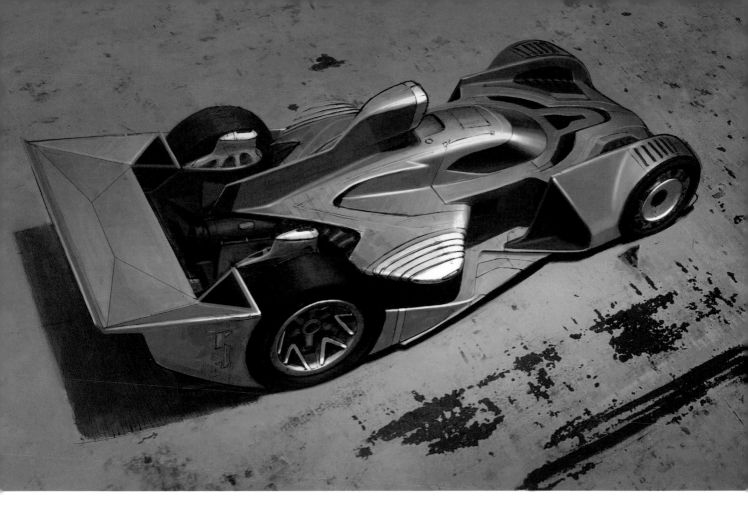

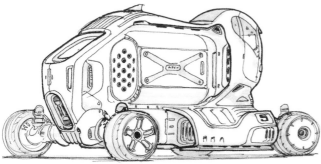

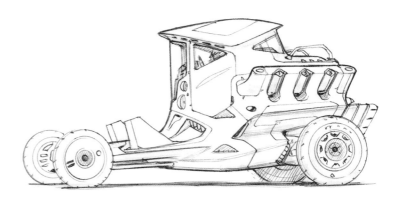

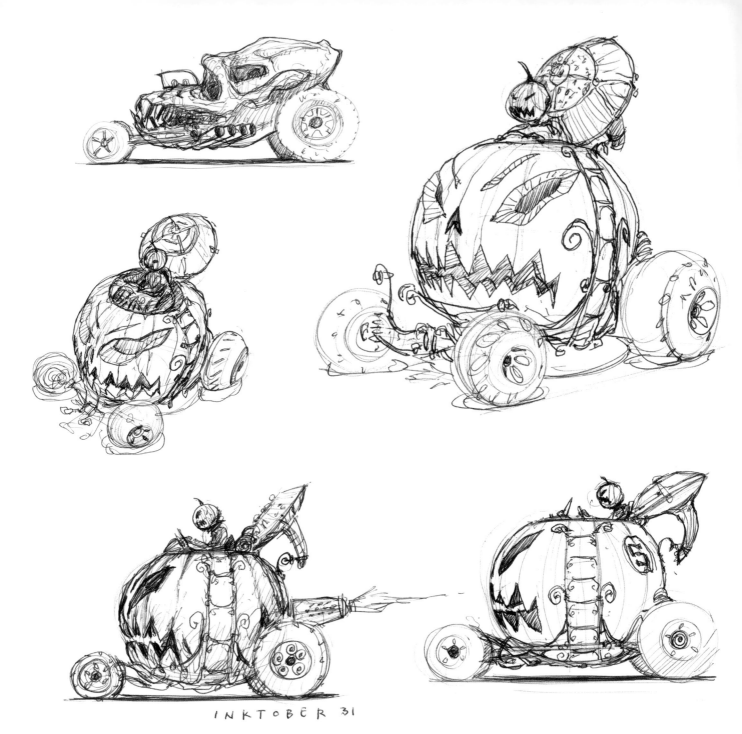

INKTOBER 31

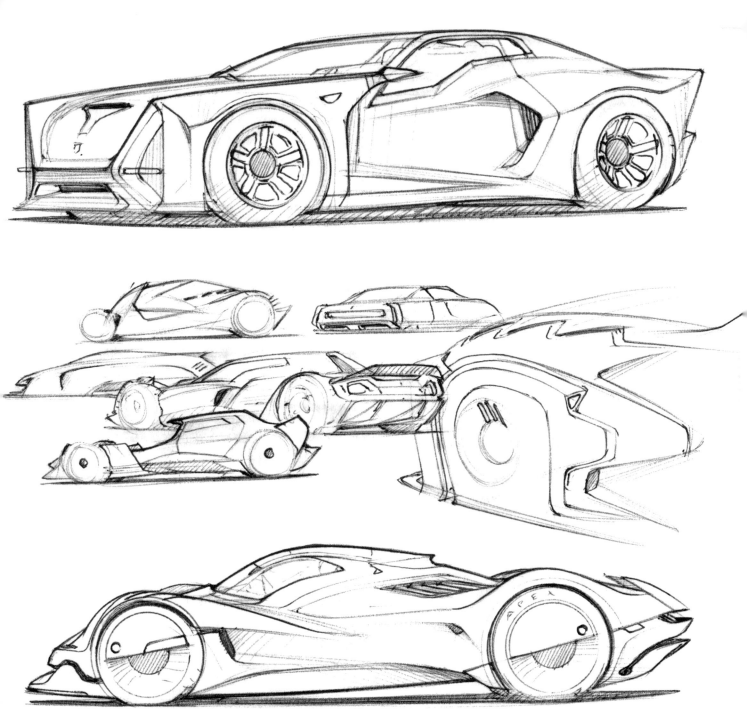

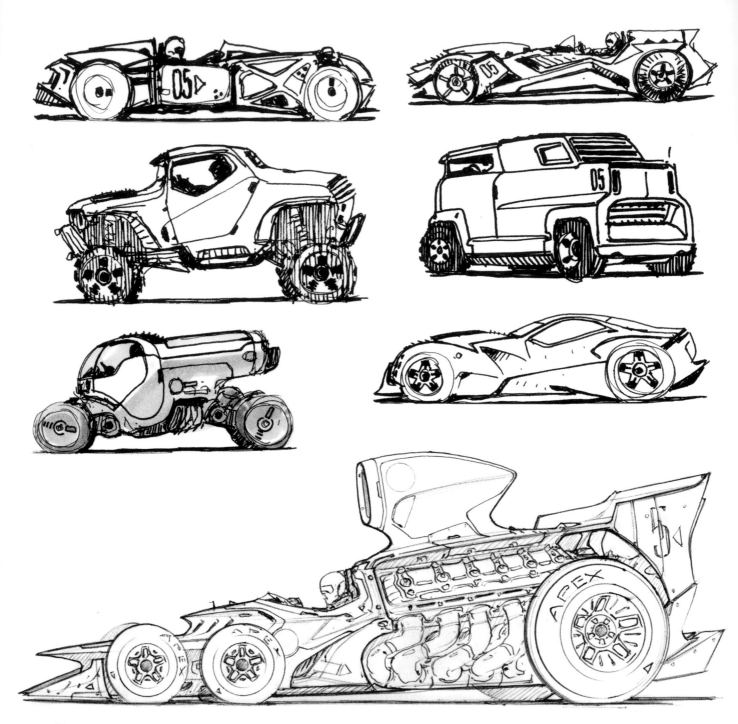

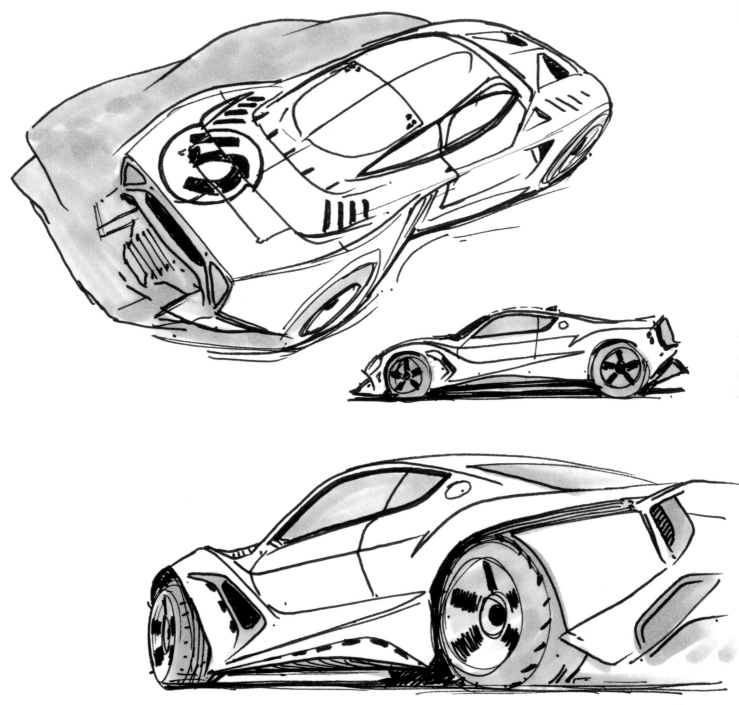

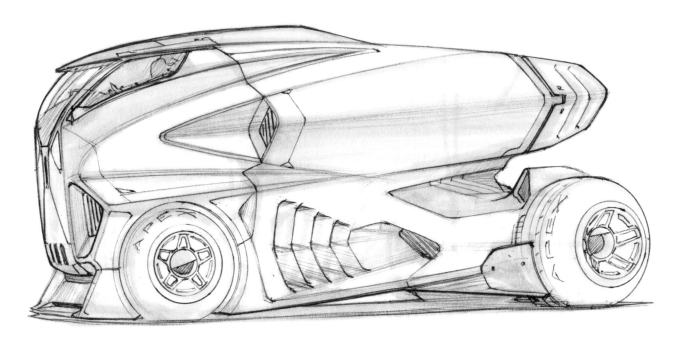

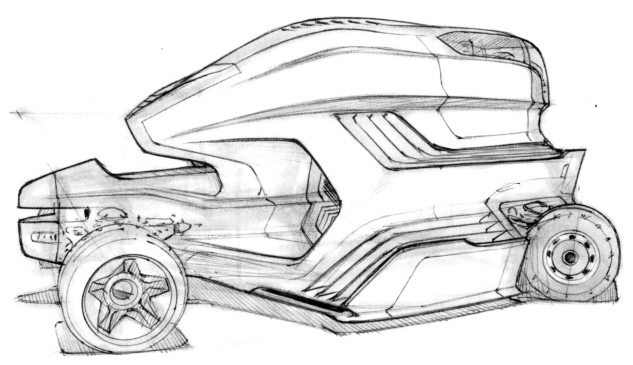

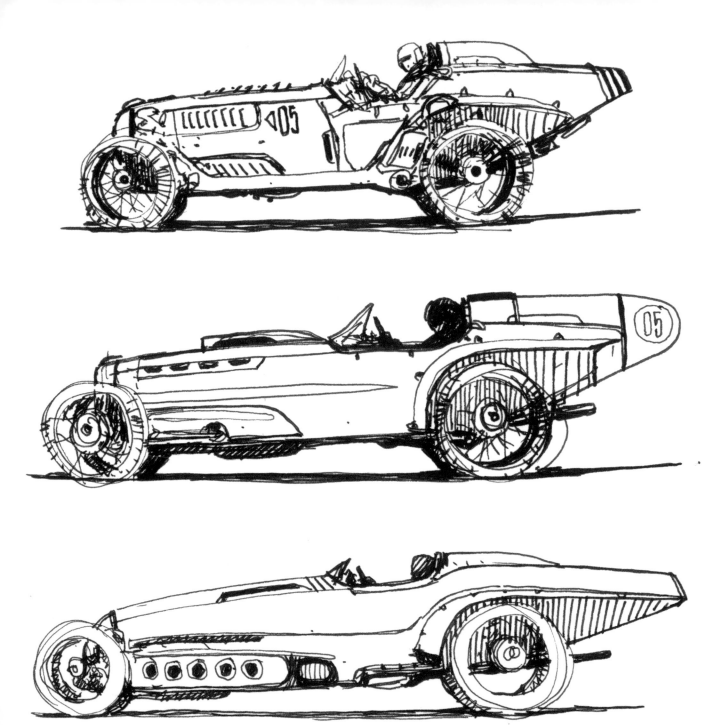

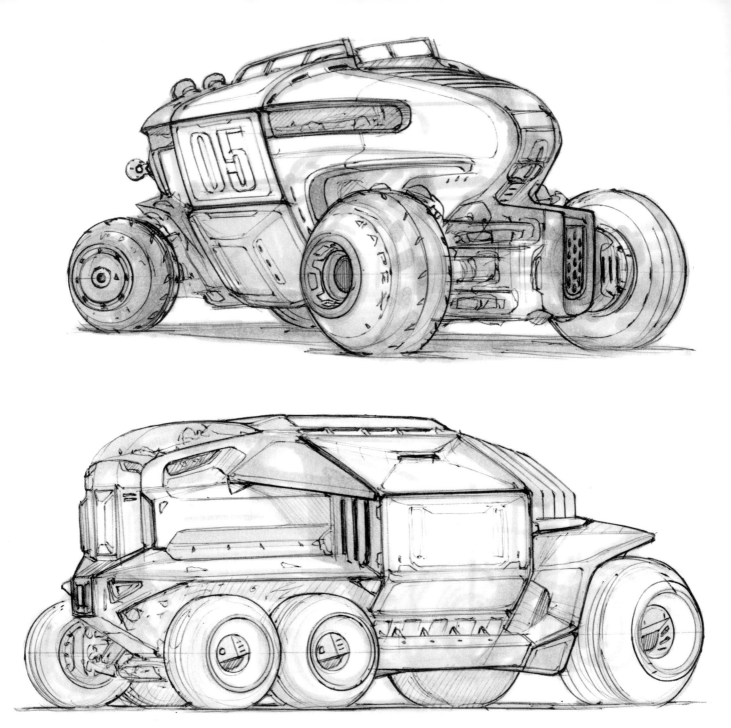

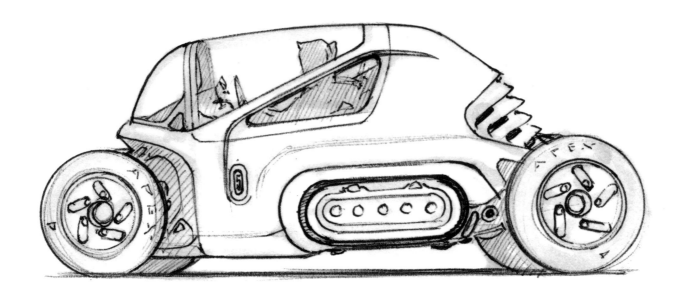

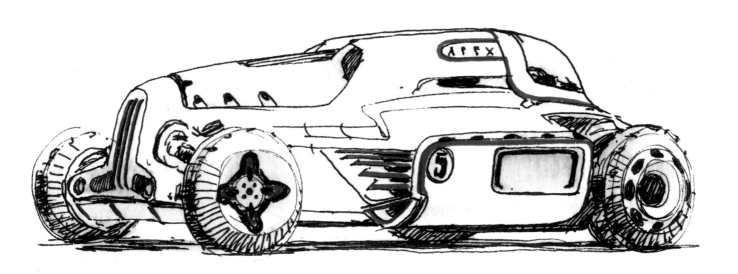

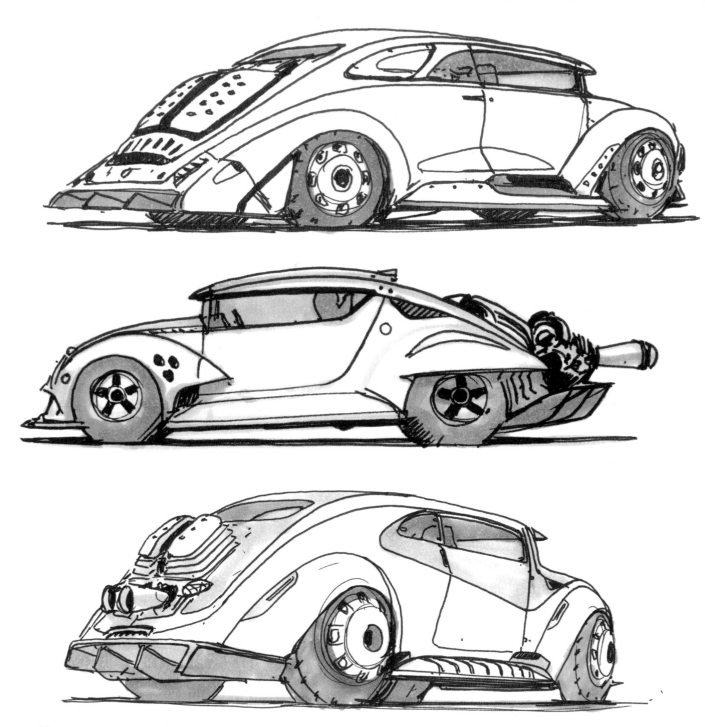

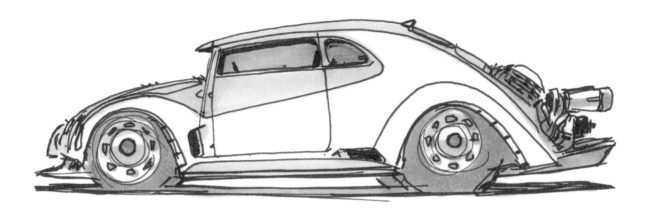

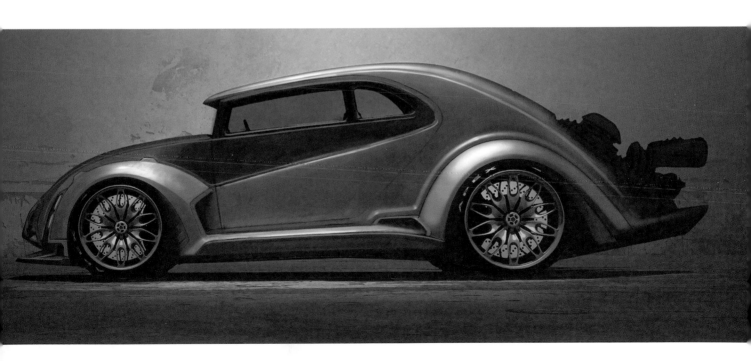

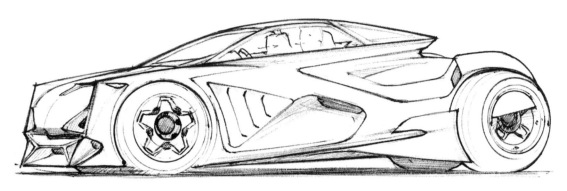

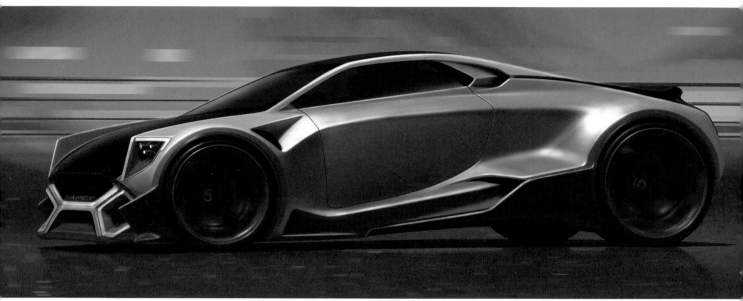

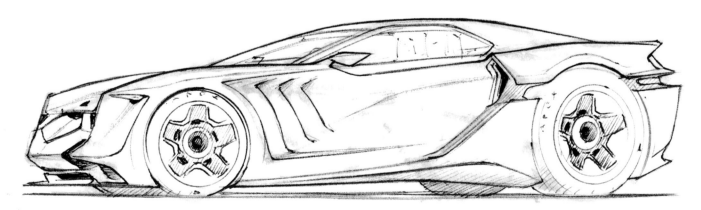

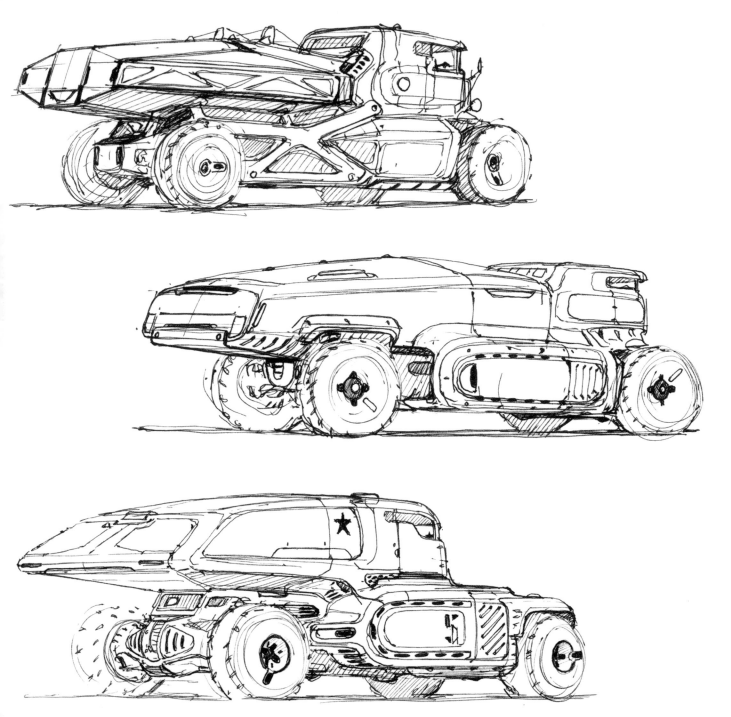

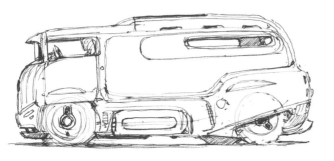

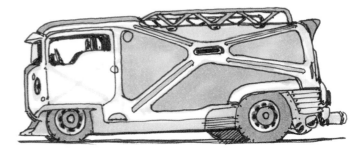

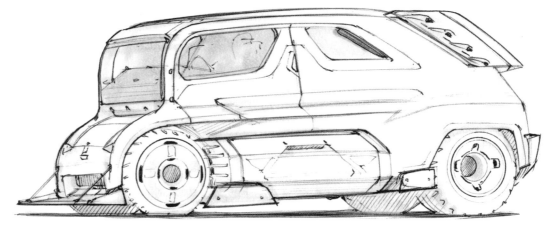

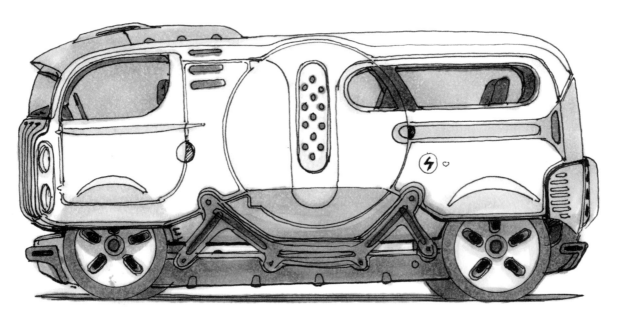

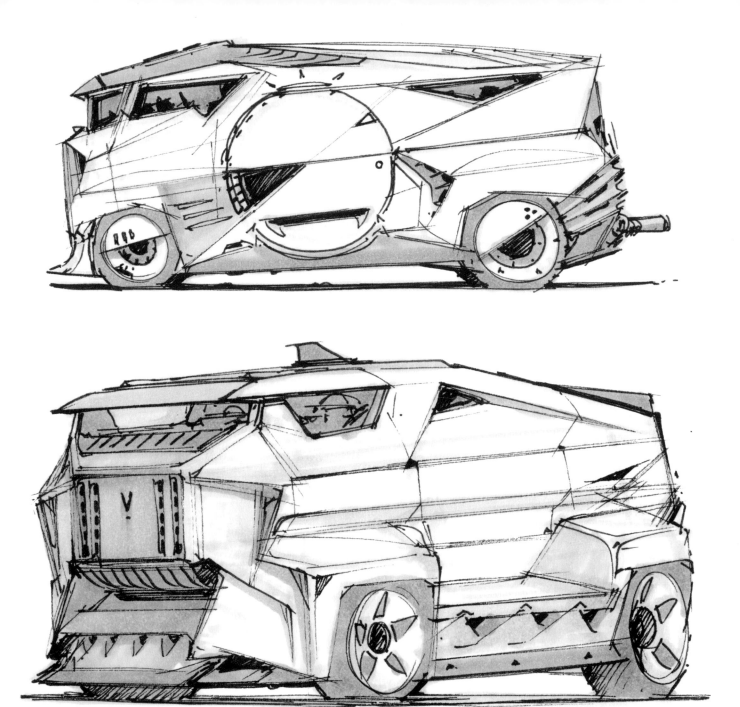

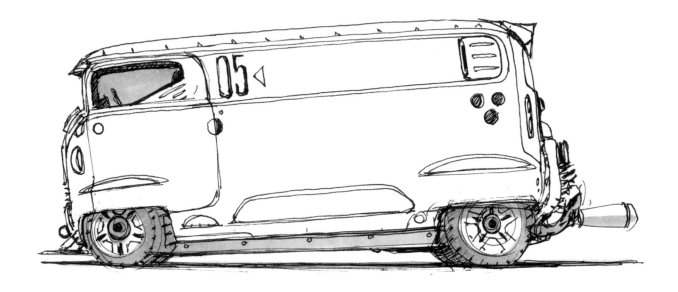

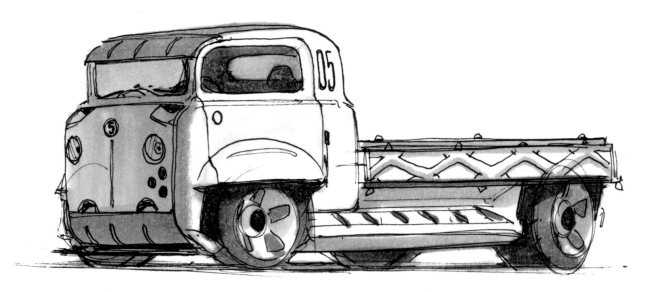

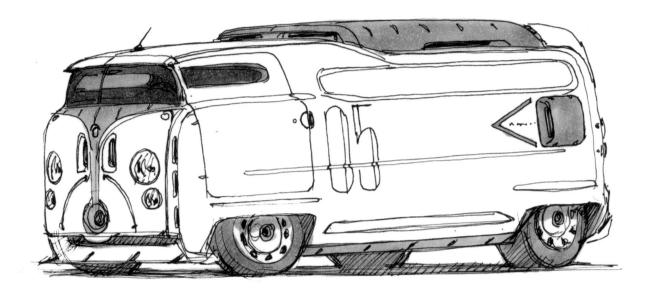

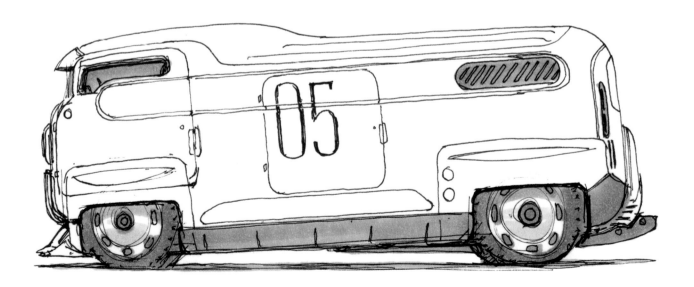

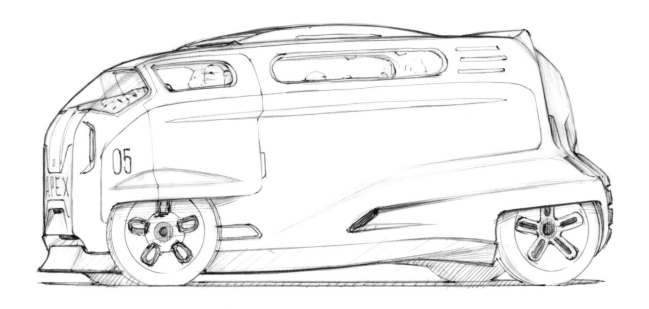

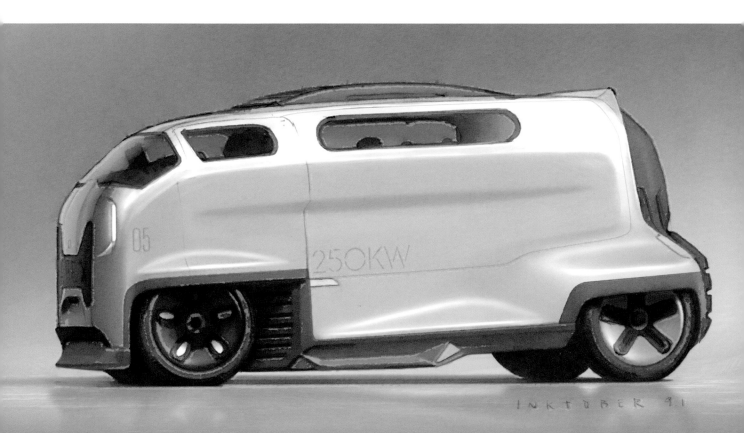

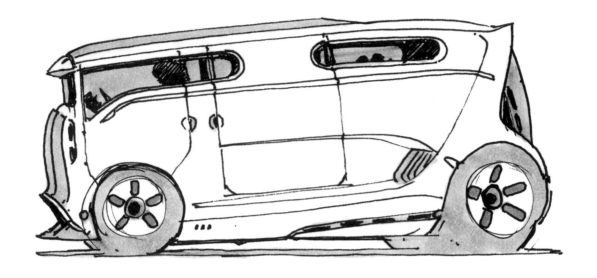

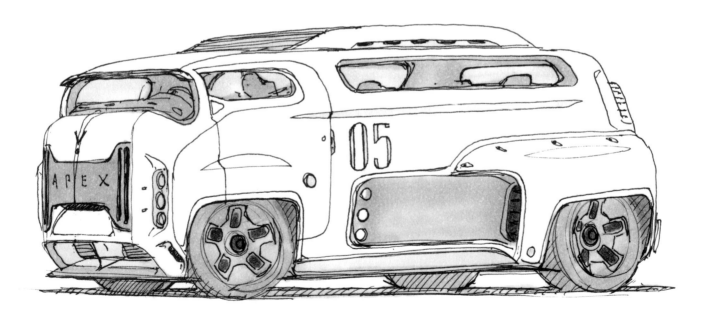

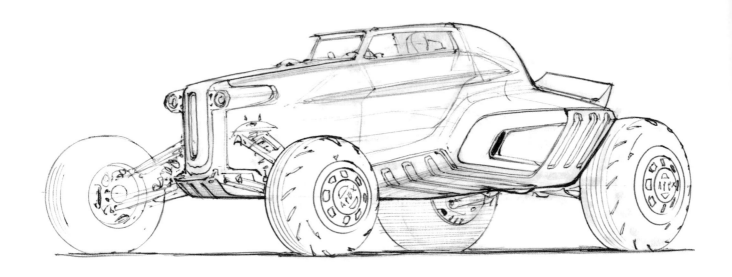

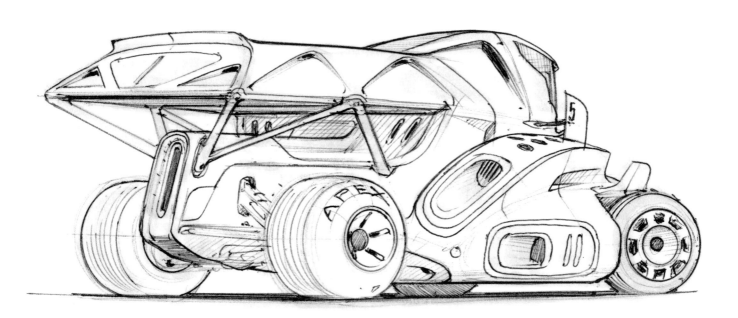

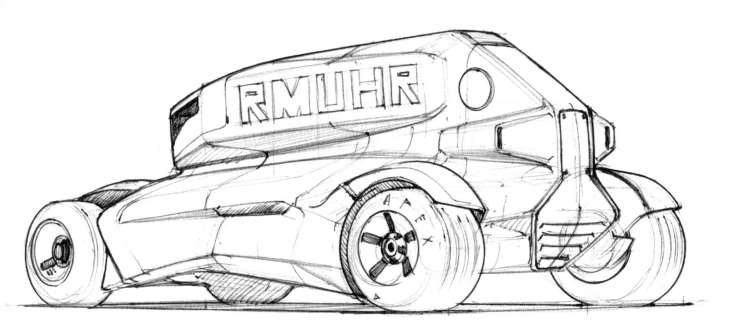

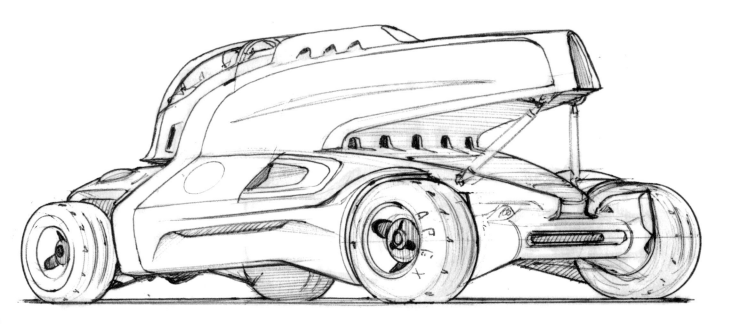

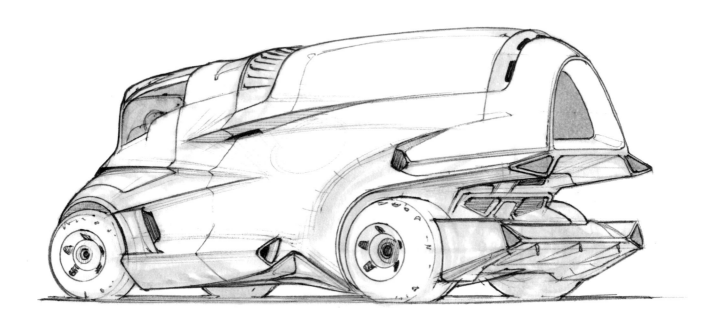

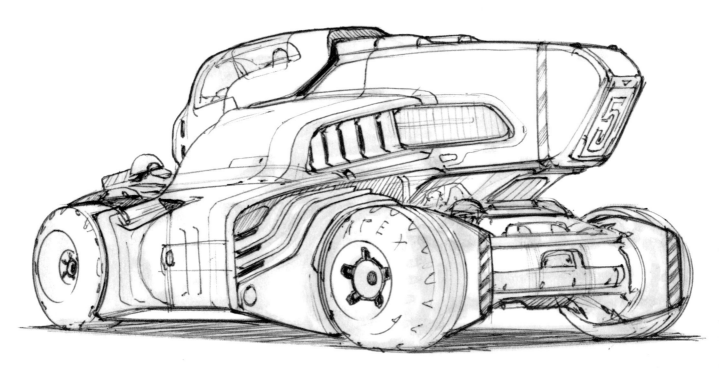

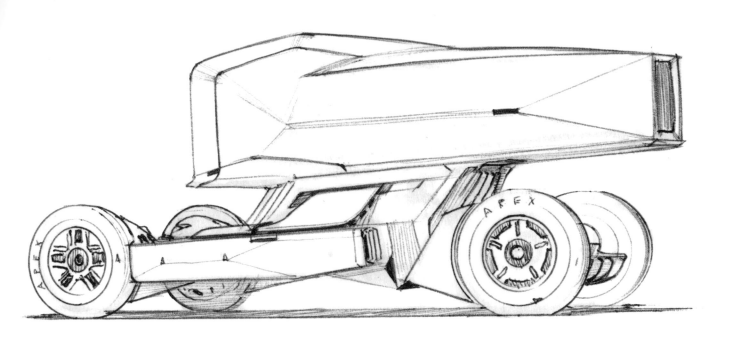

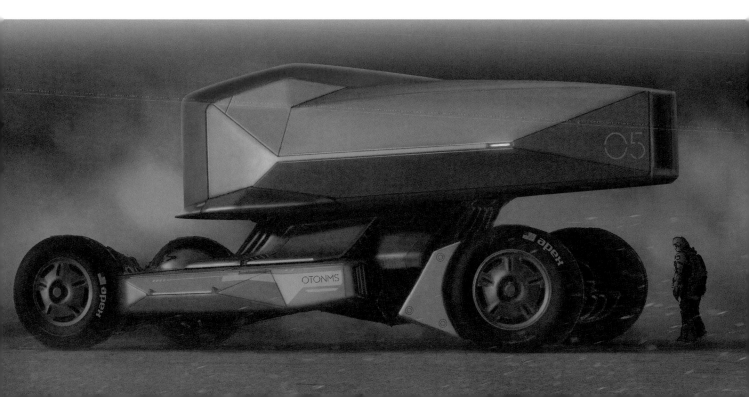

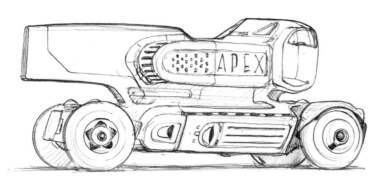

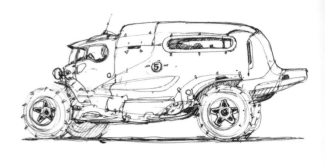

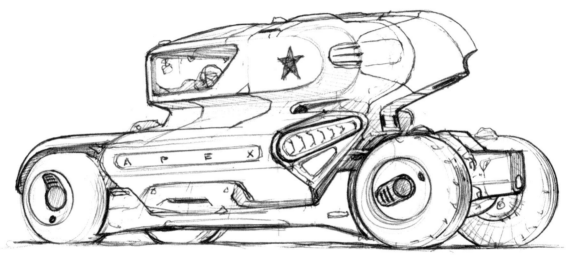

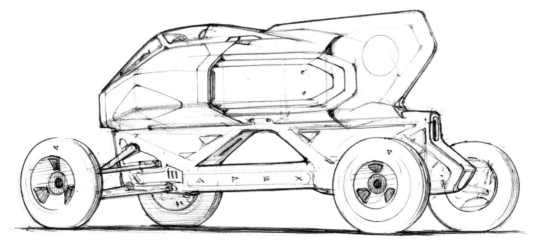

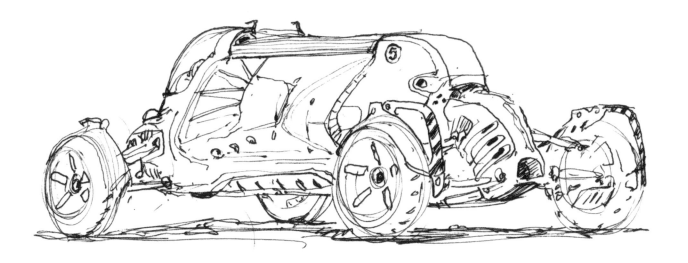

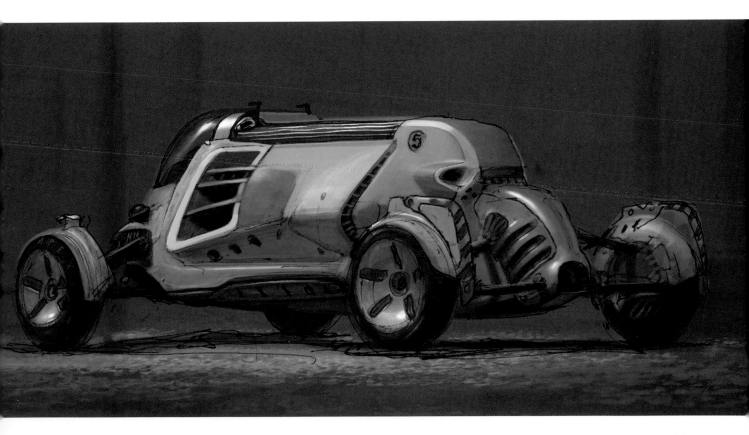

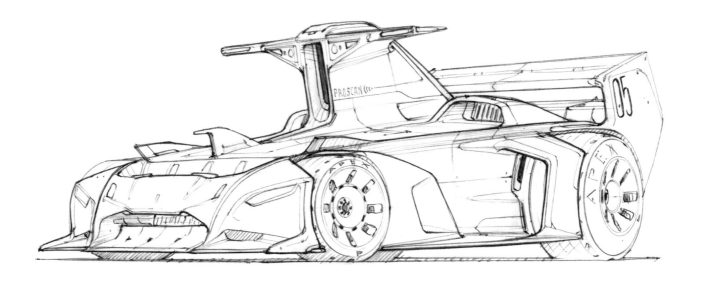

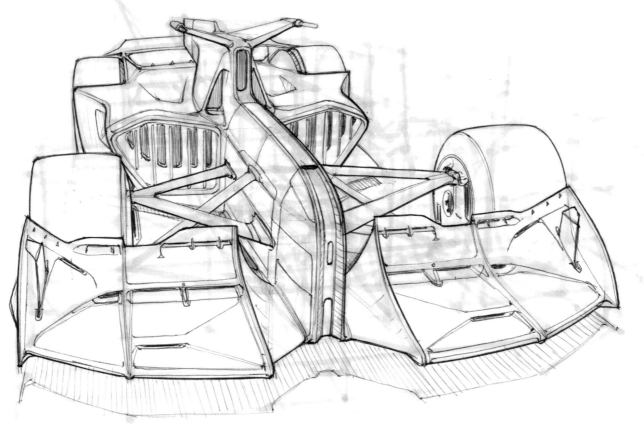

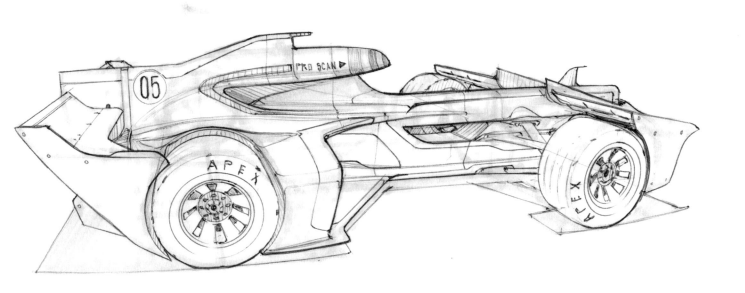

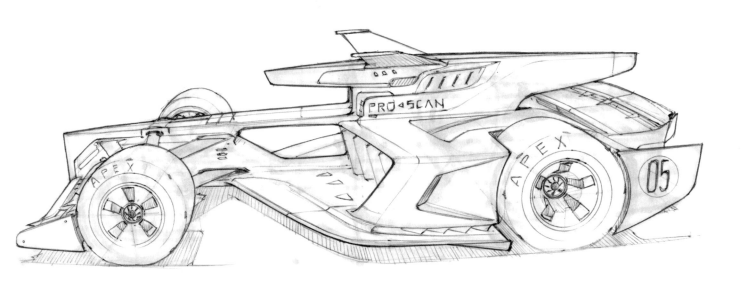

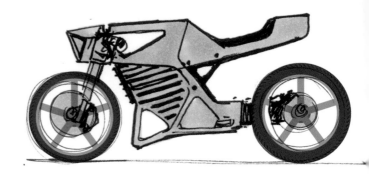
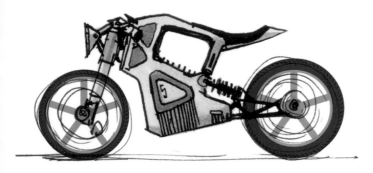
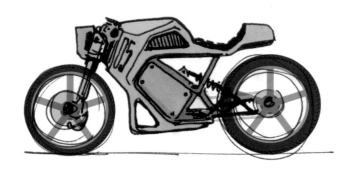
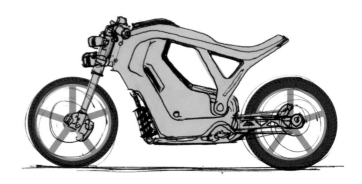
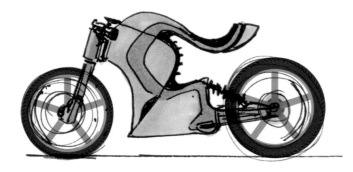
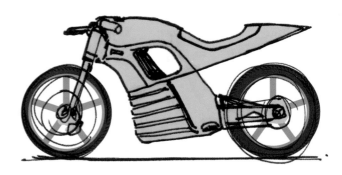

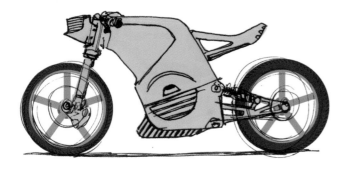

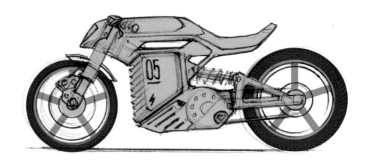

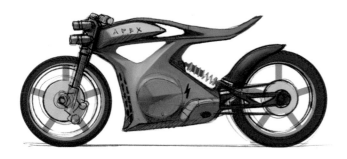

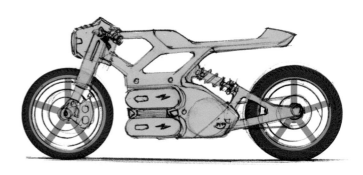

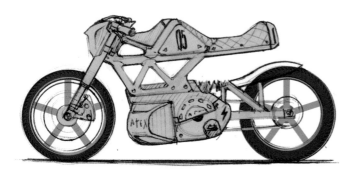

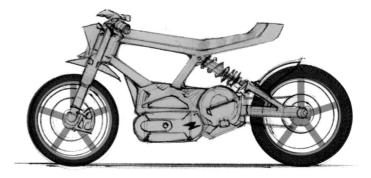

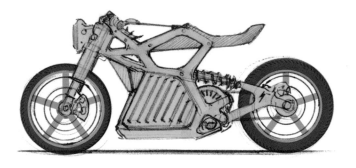

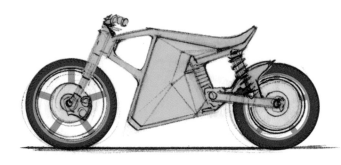

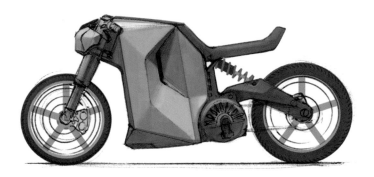

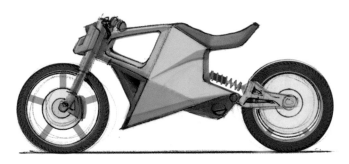

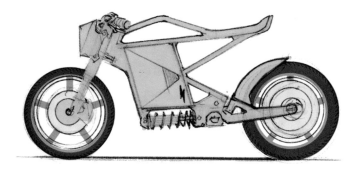

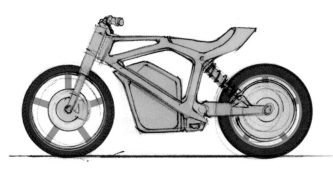

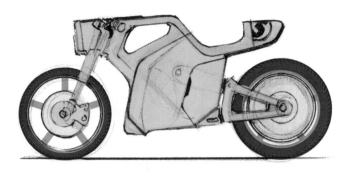
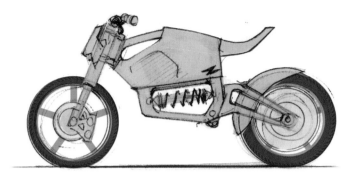
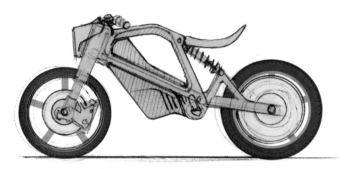
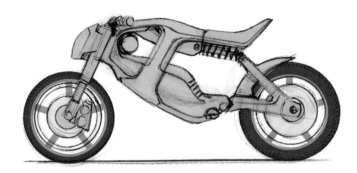
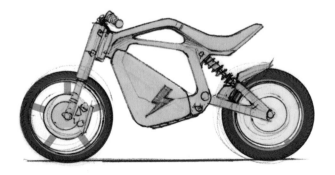
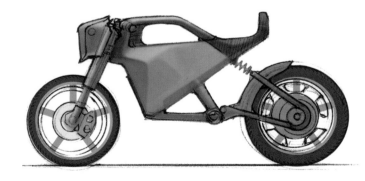

Scott Robertson | **SKETCH COLLECTION: volume 2** ———— **57**

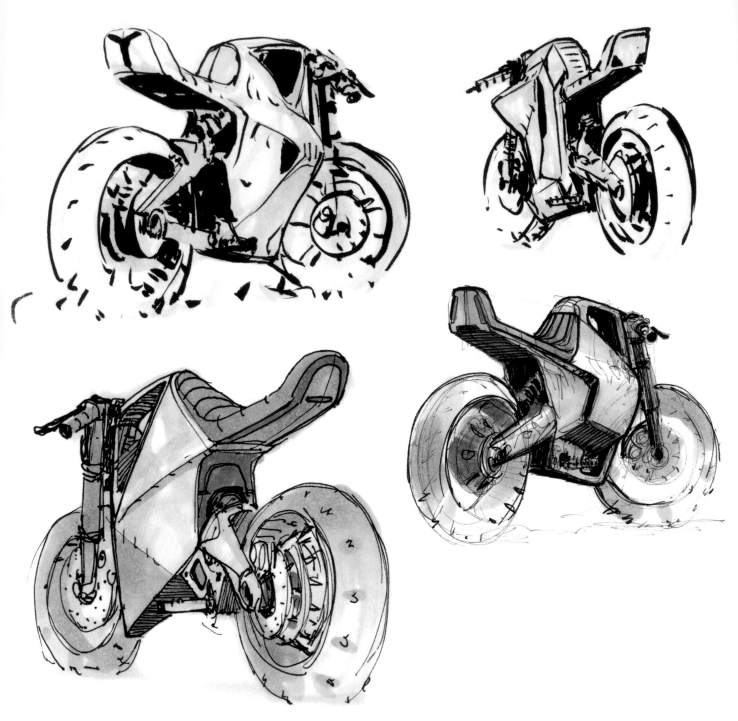

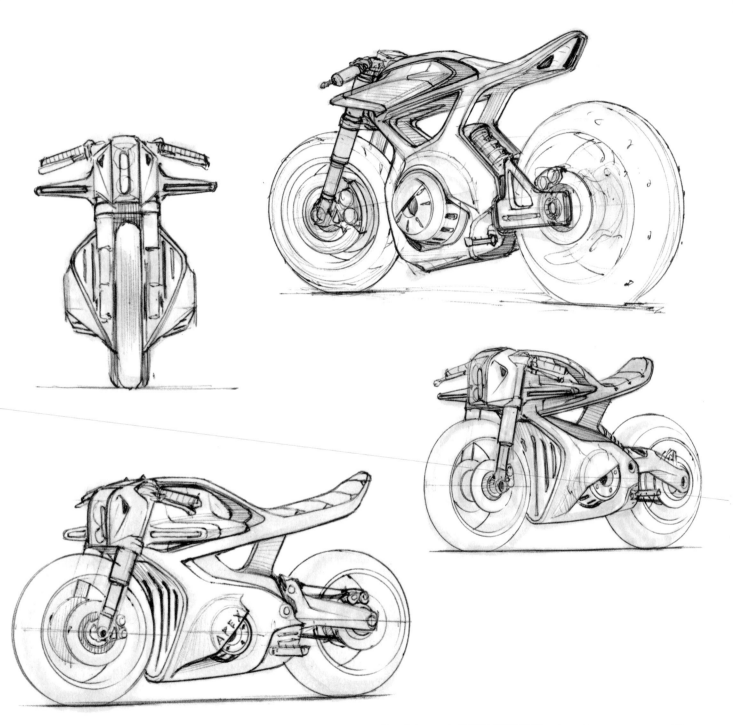

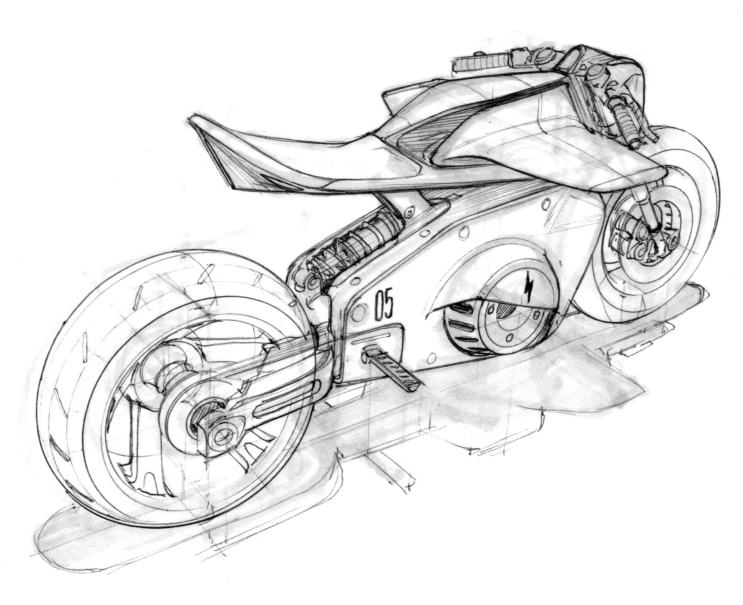

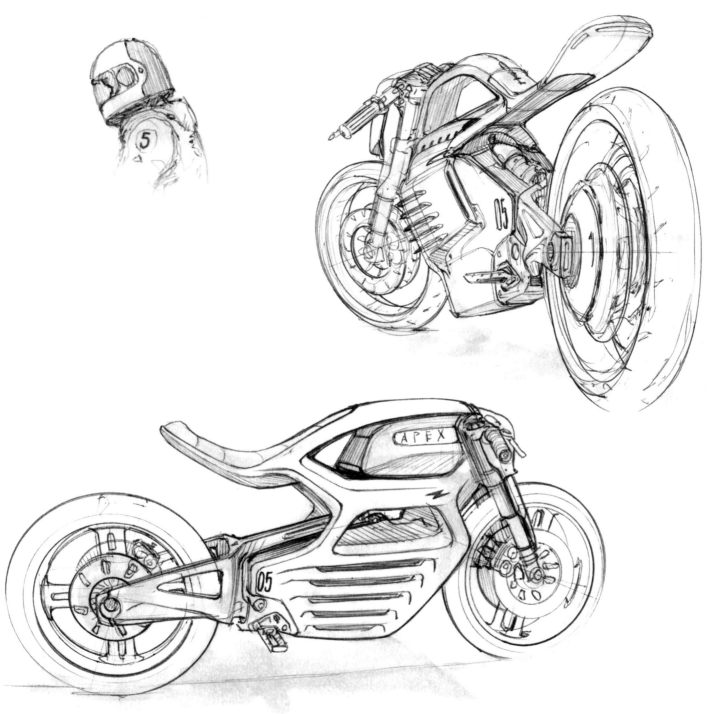

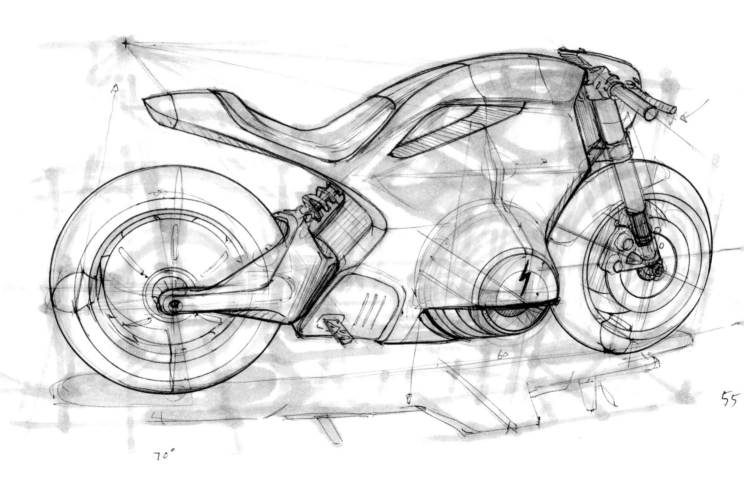

70° 60 55

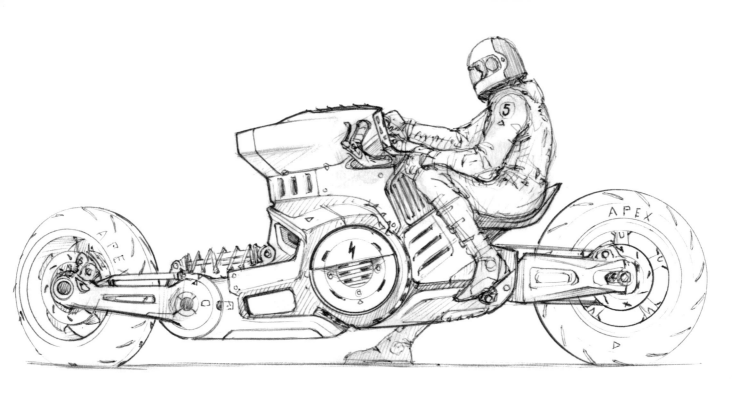

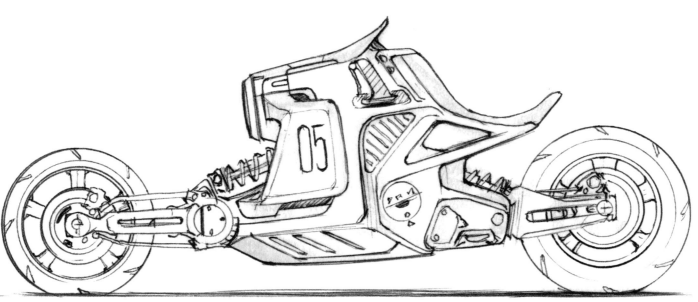

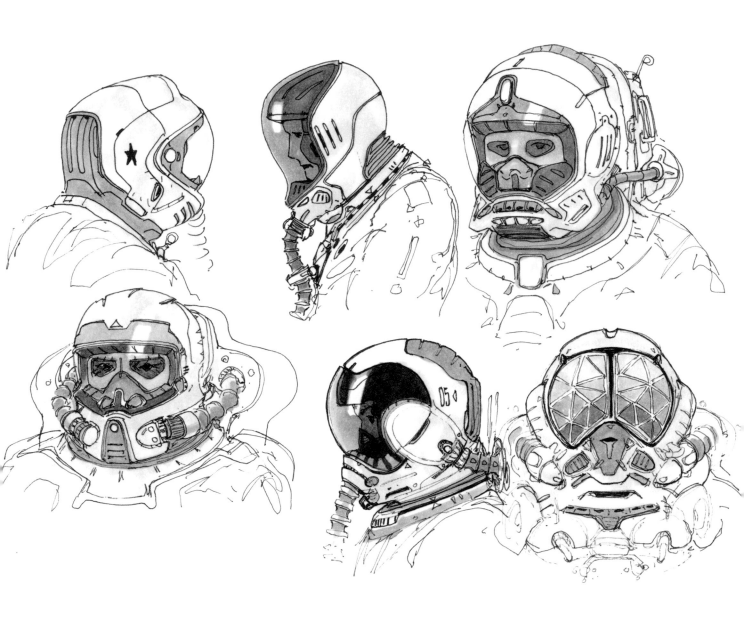

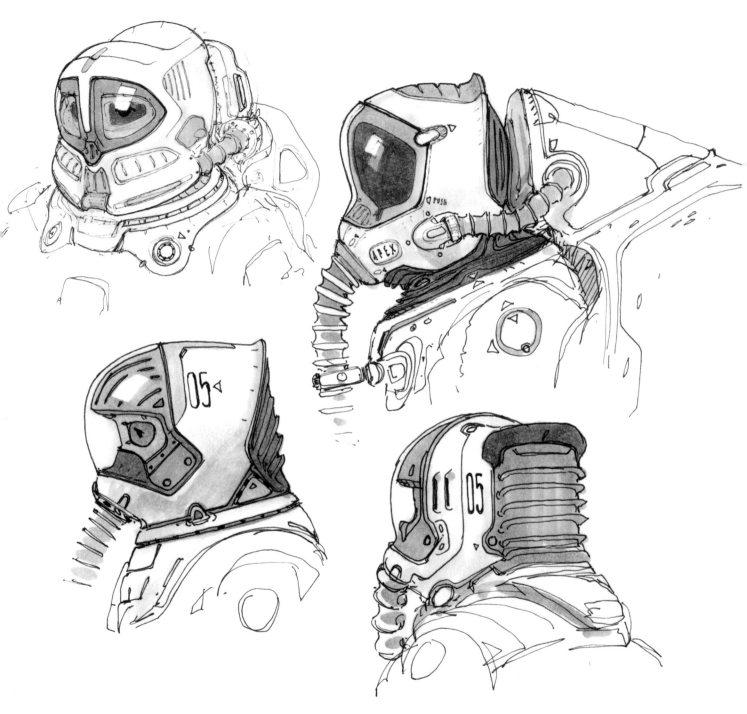

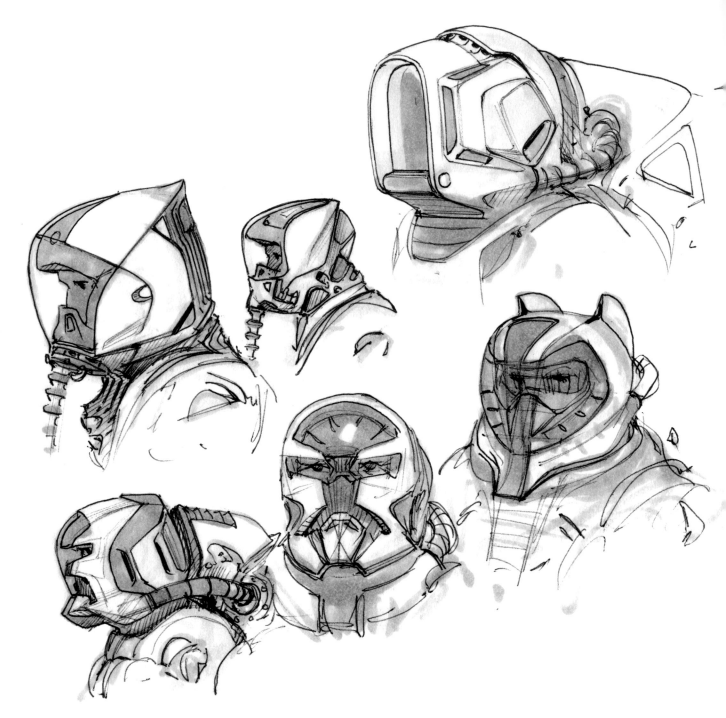

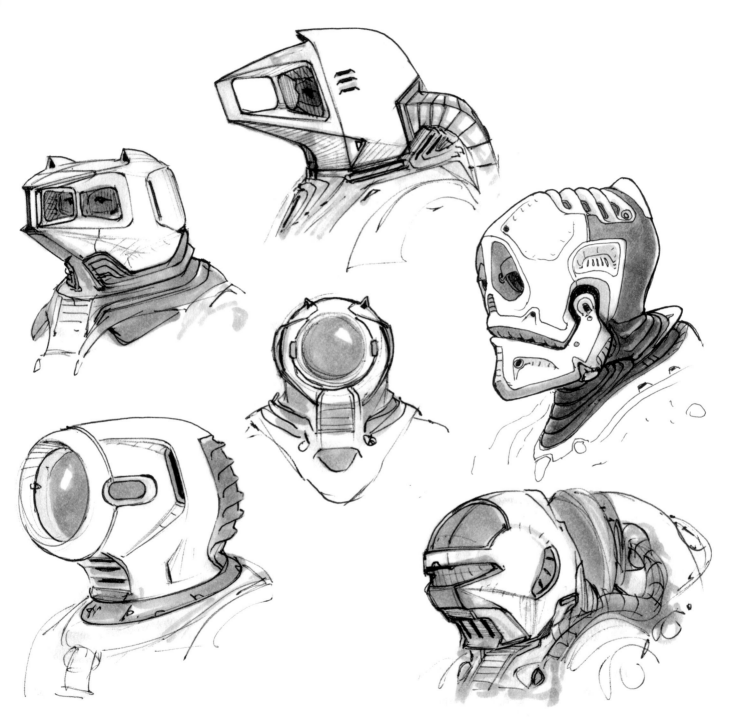

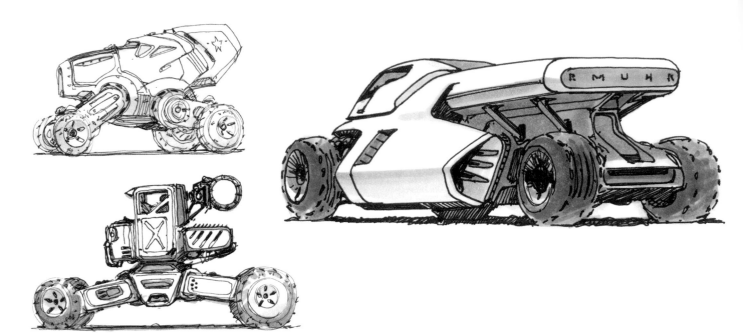
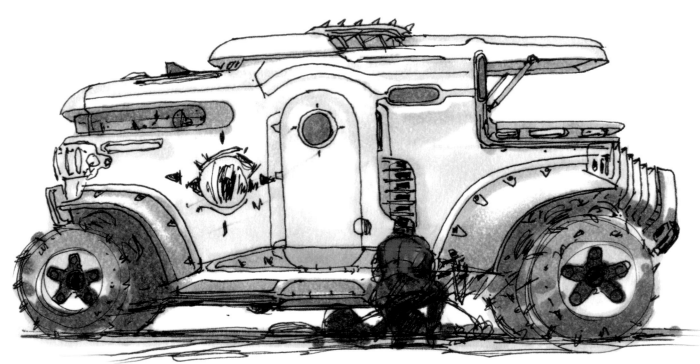

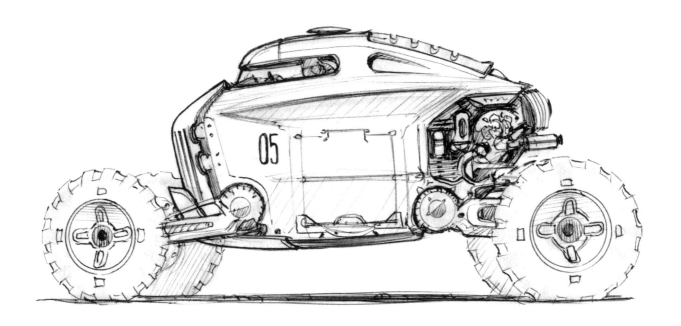

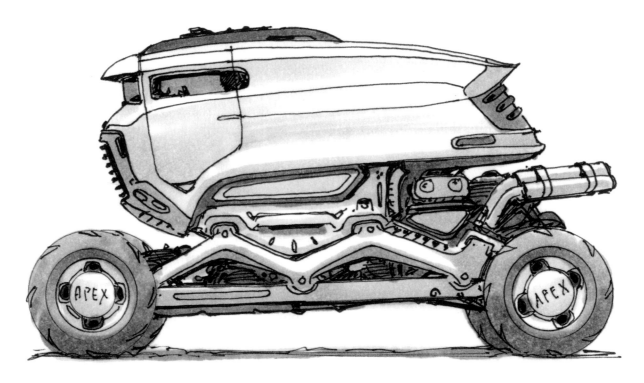

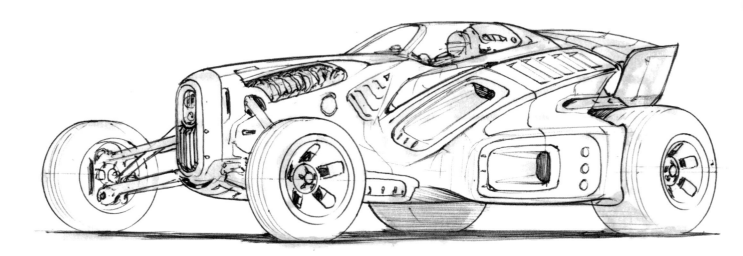

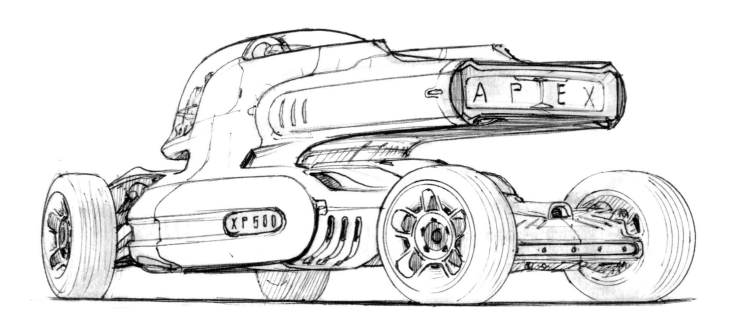

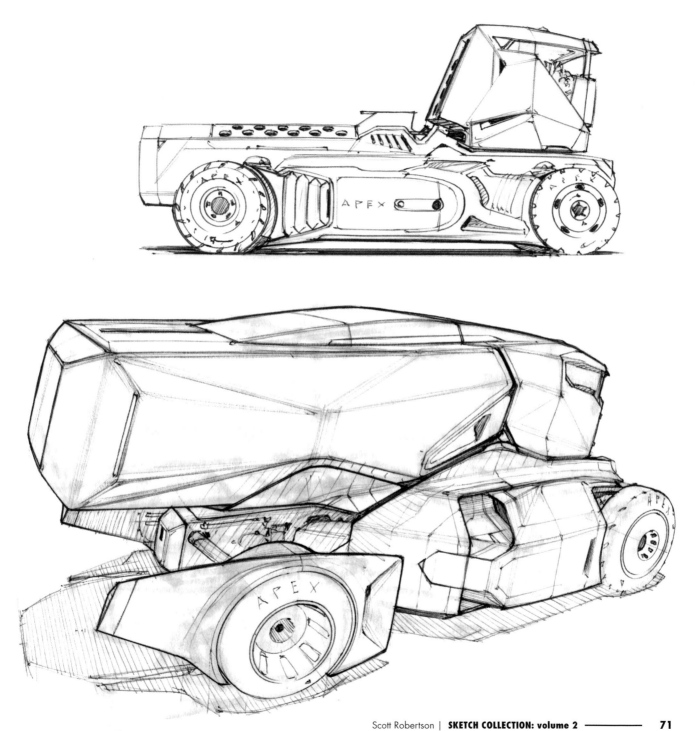

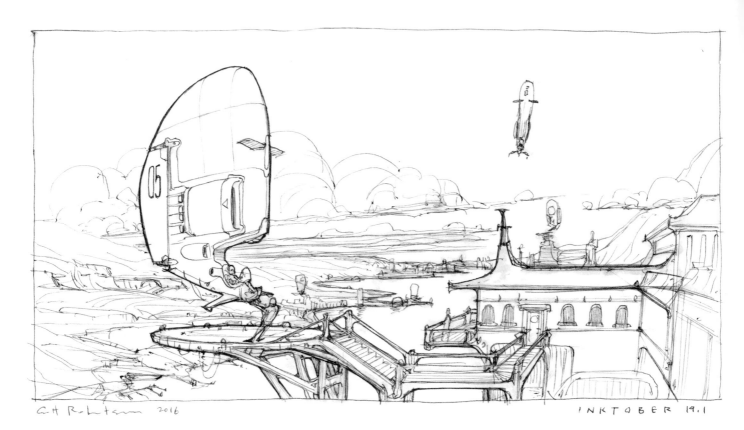

C.H. Robertson 2016 I N K T O B E R 19.1

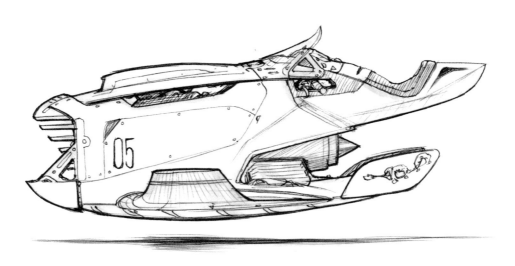

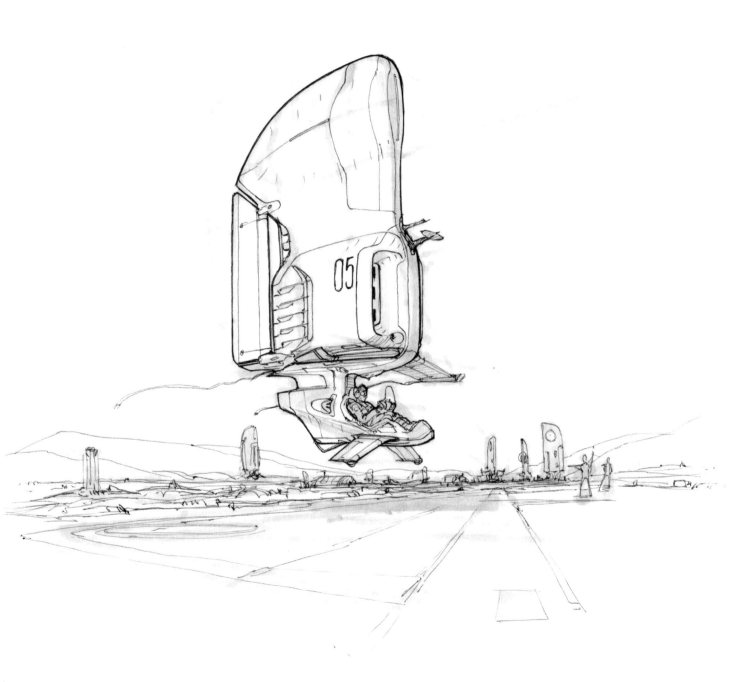

GR ▶
YT ▶

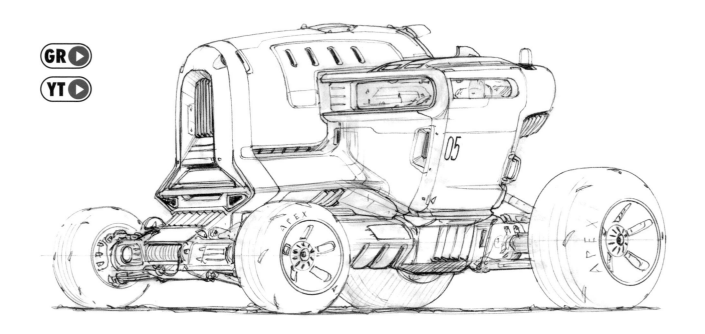

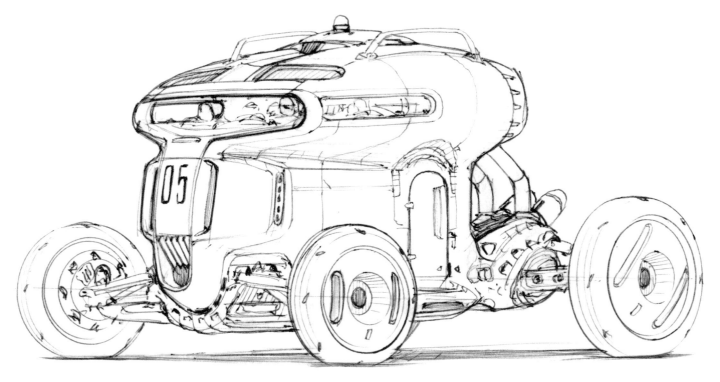

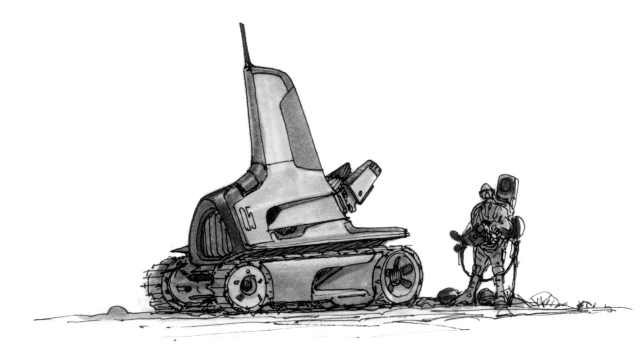

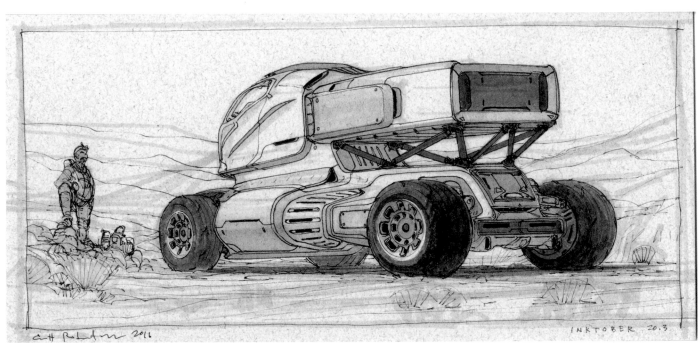

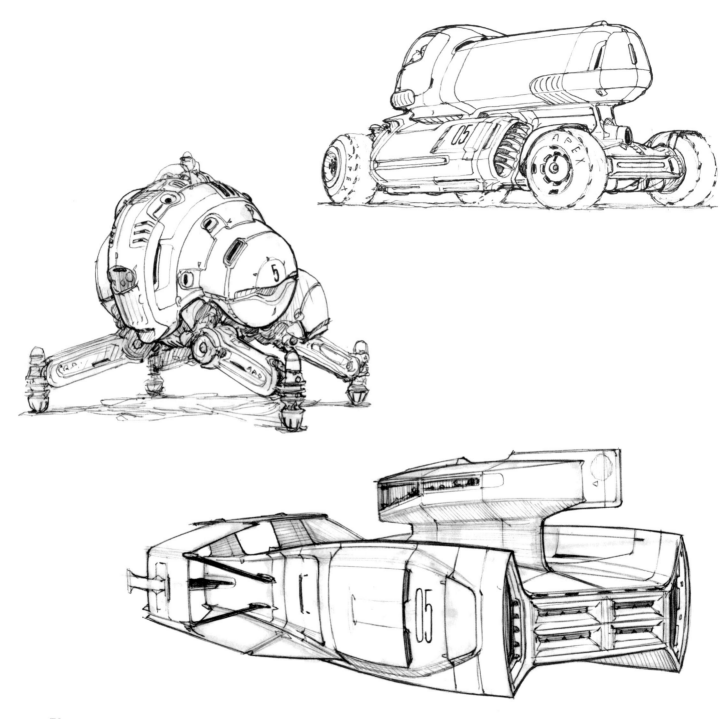

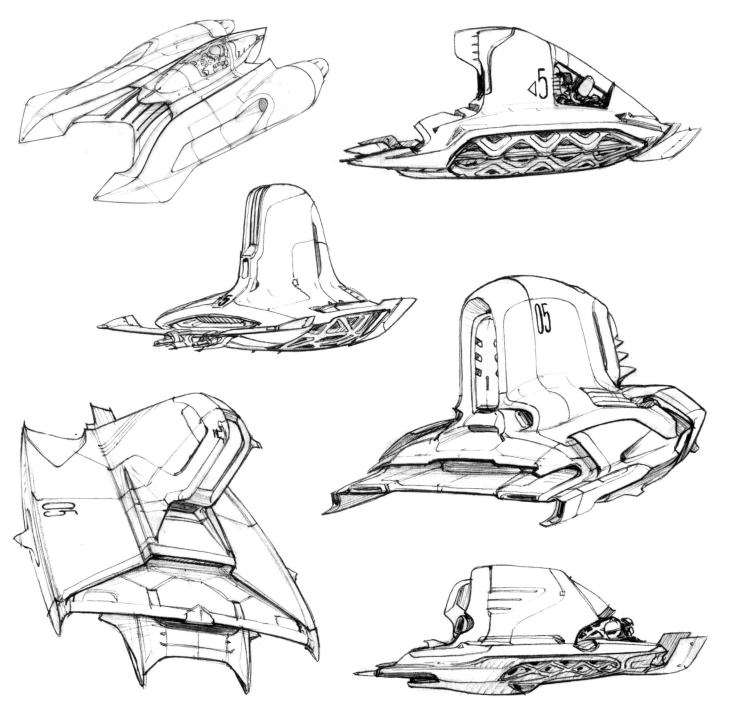

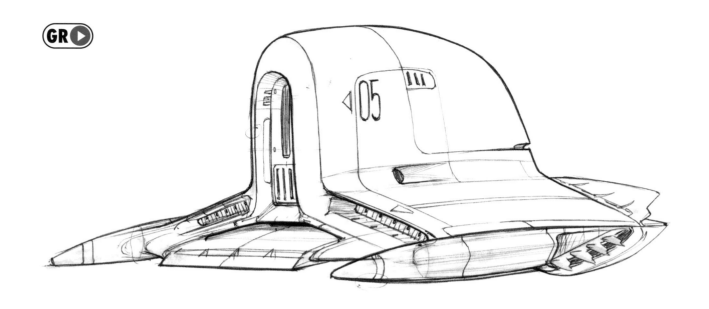

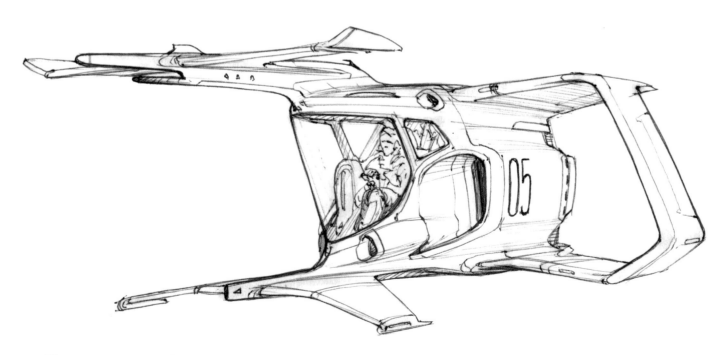

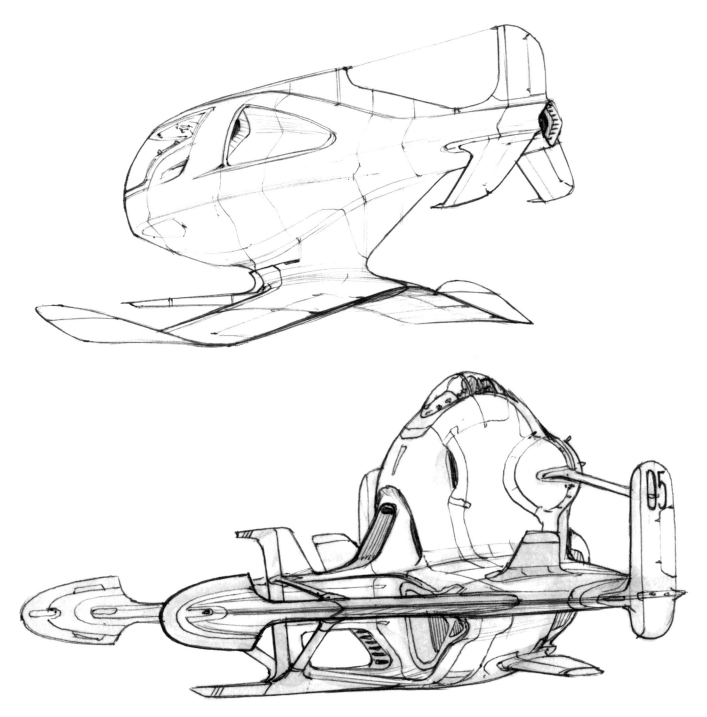

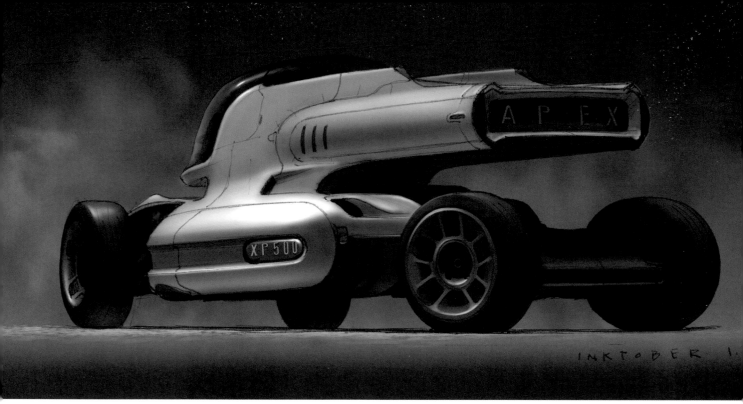

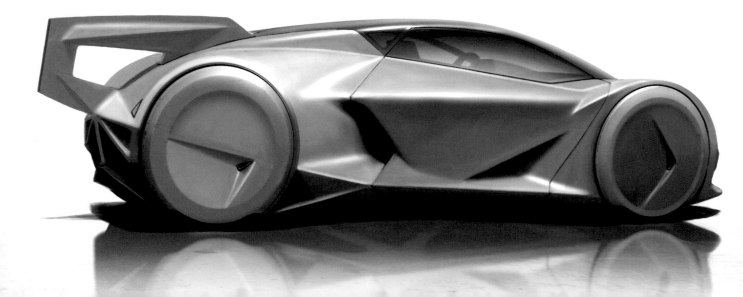

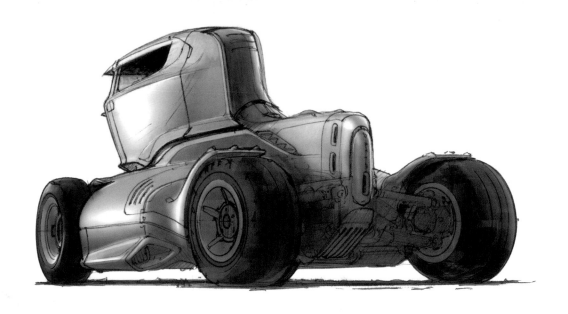

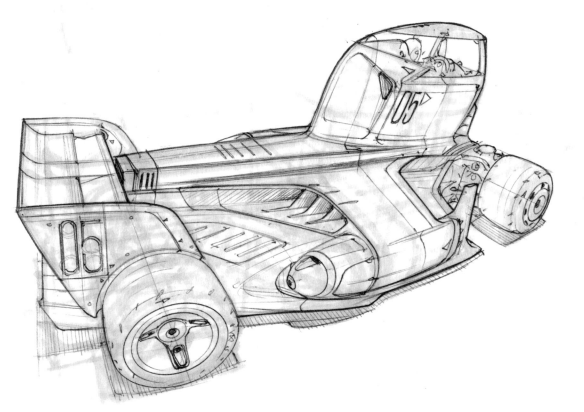

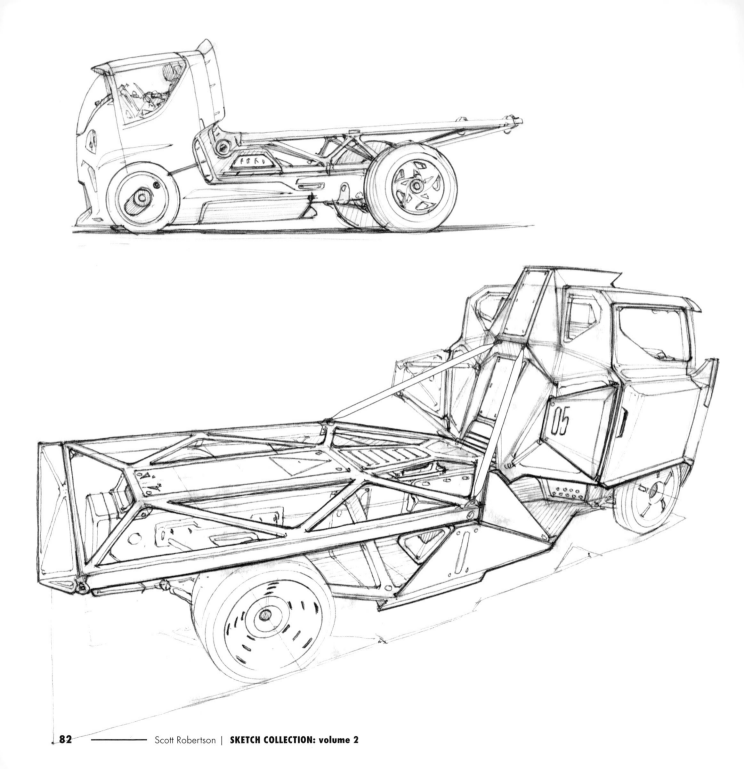

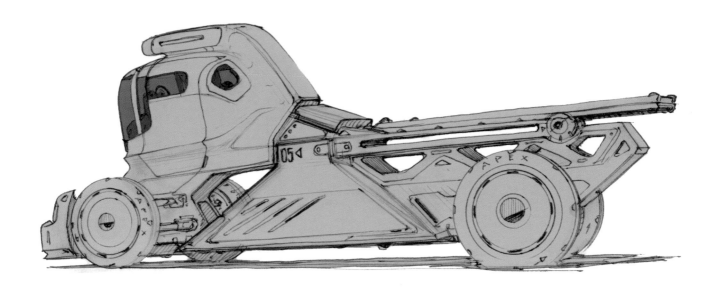

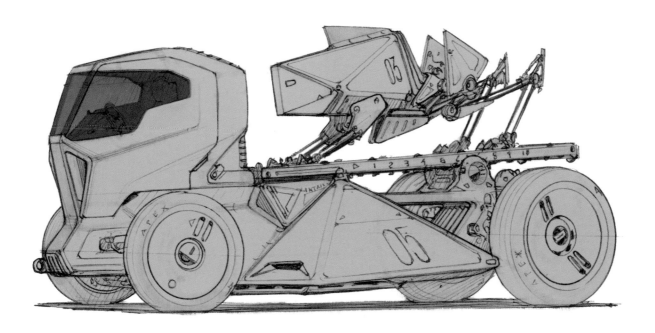

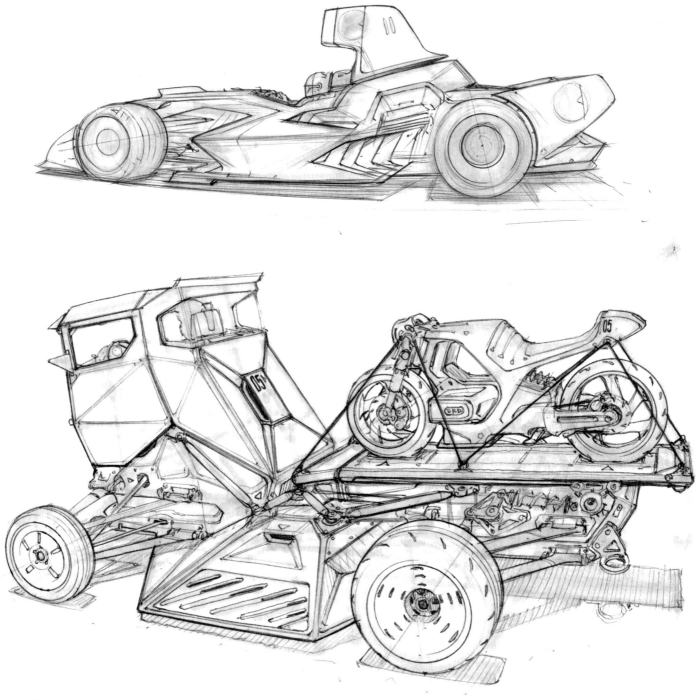

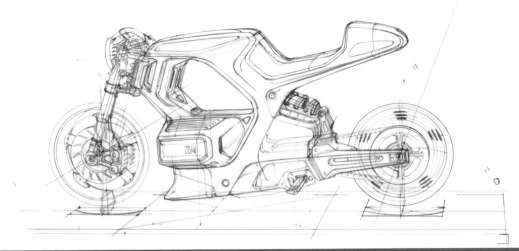

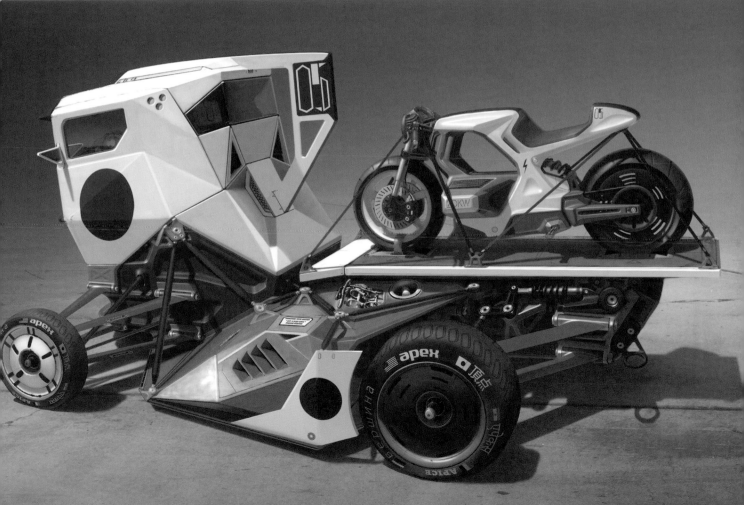

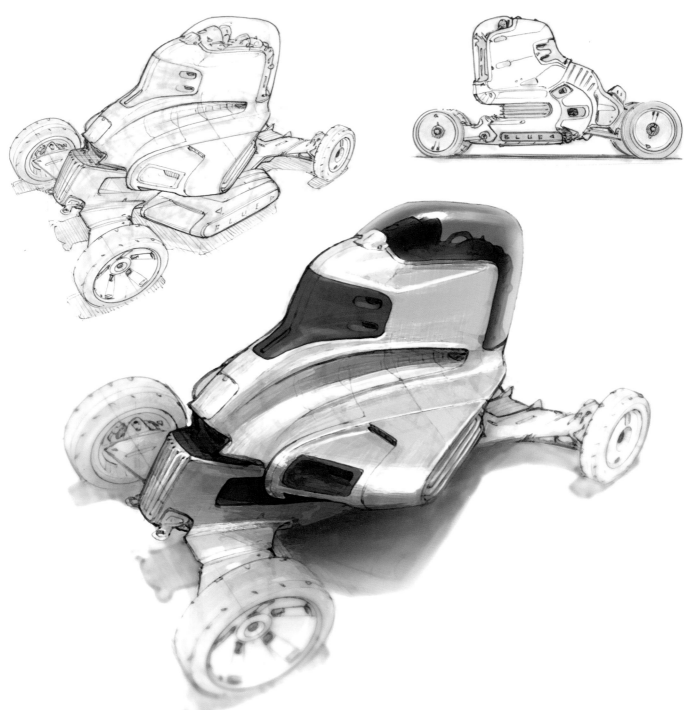

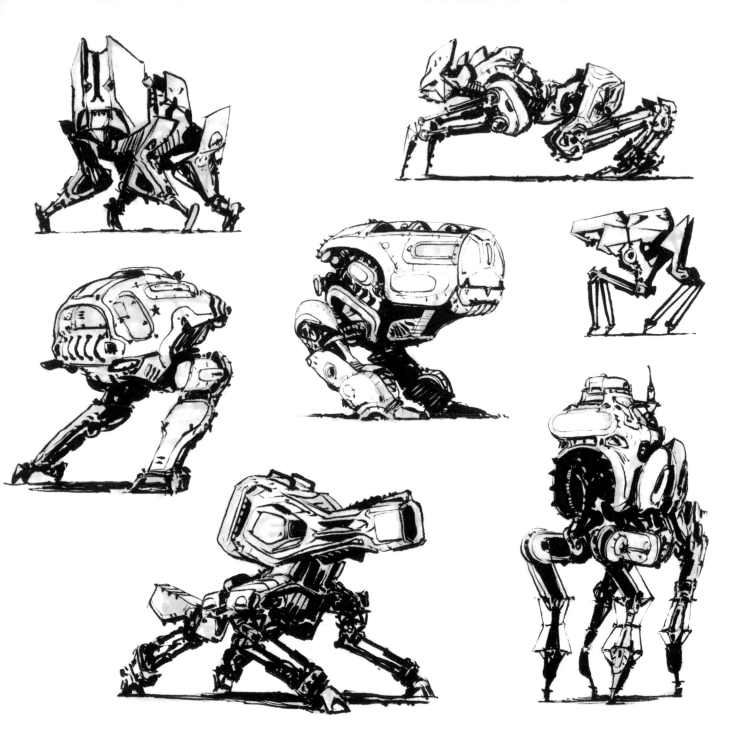

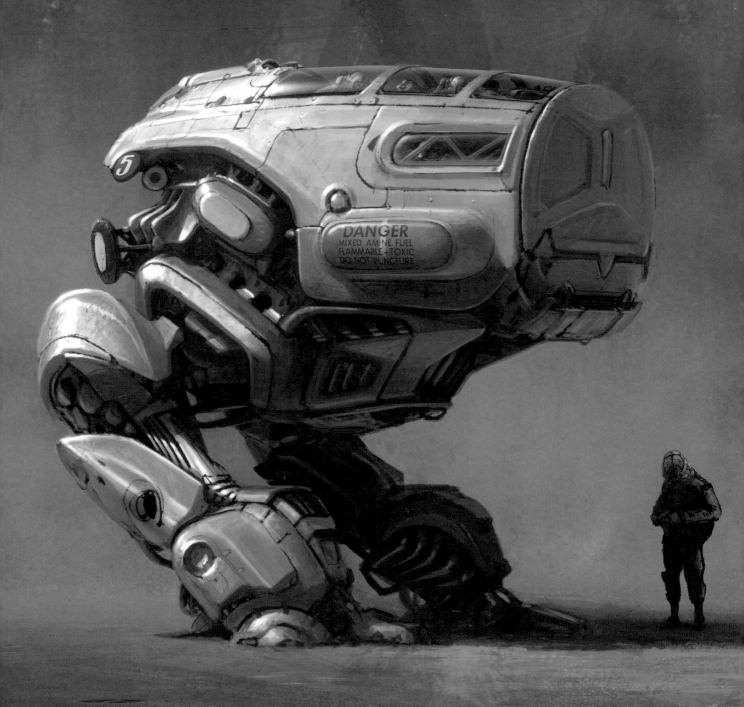

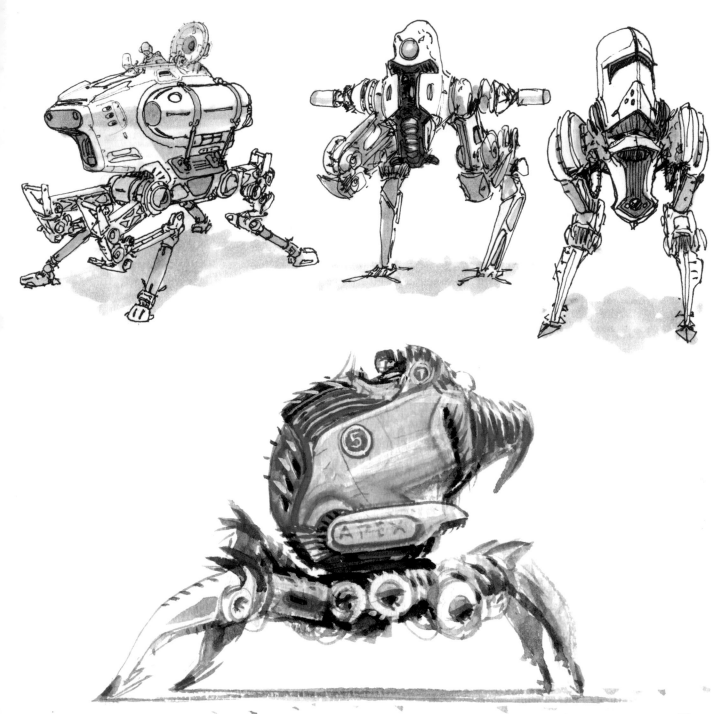

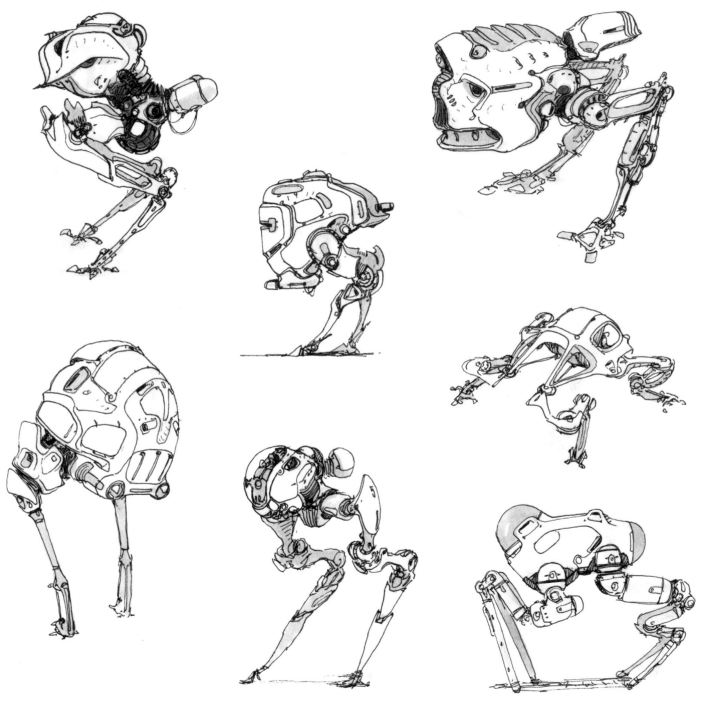

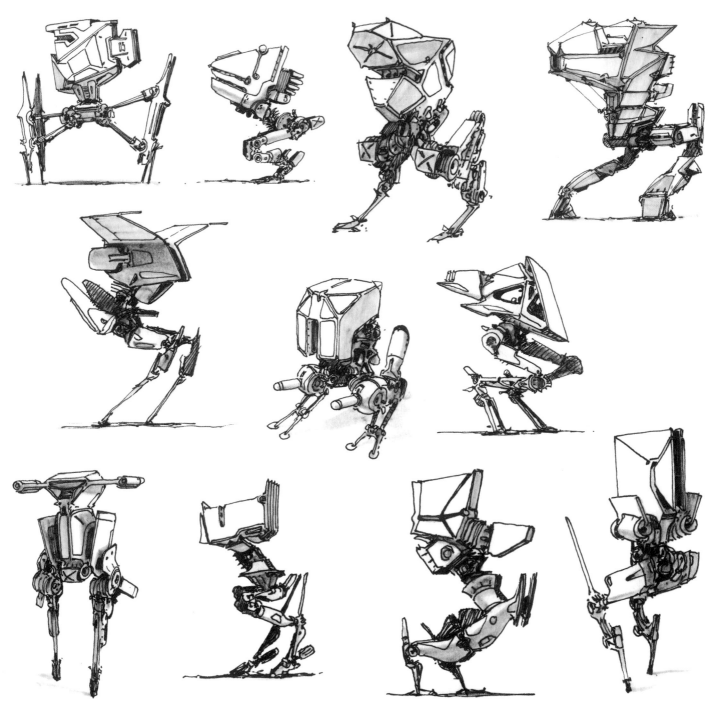

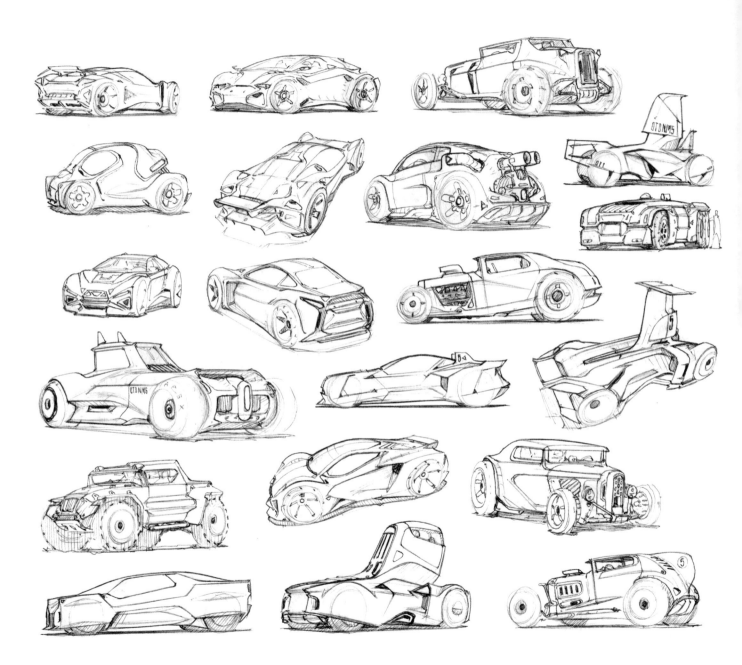

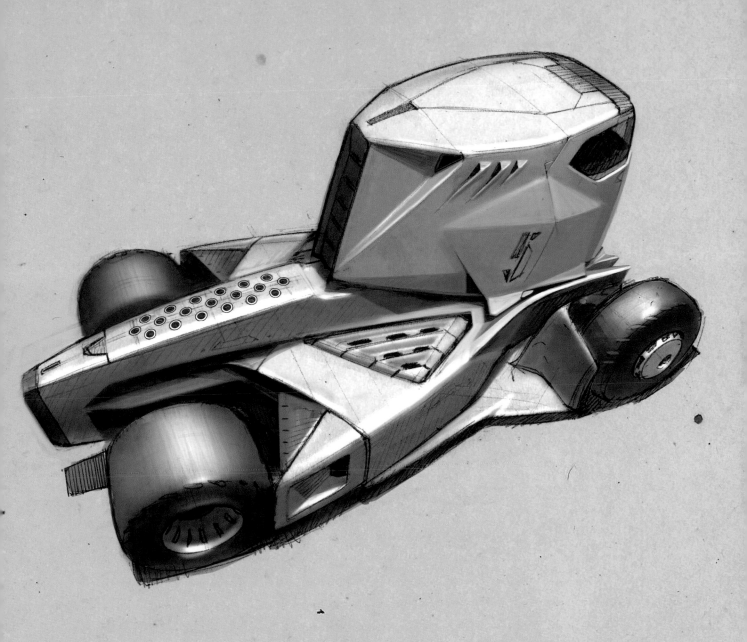

Scott Robertson
Former Chair of Entertainment Design: Art Center College of Design
Designer / Author / Educator / Co-Producer

With over 18 years of experience teaching and creating curriculum on how to design, draw, and render at the highest college level, Scott brings unique and unquestioned expertise to the presentation and communication of the subject of this book. He has authored or co-authored 11 books on design and concept art. In addition to books, he has co-produced over 40 educational DVDs with The Gnomon Workshop of which 9 feature his own lectures. Scott formerly chaired the Entertainment Design department at Art Center College of Design that he helped to create. He frequently lectures around the world for various corporations, colleges, and through his own workshop brand, SRW.

In addition to teaching, Scott has worked on a very wide variety of projects ranging from vehicle and alien designs for the Hot Wheels animated series *Battle Force Five*, to theme park attractions such as the *Men in Black* ride in Orlando, Florida for Universal Studios. Some of his clients have included the BMW subsidary Design-works/USA, Bell Sports, Giro, Mattel Toys, Spin Master Toys, Patagonia, the feature film *Minority Report*, Nike, Rockstar Games, Sony Online Entertainment, Sony Computer Entertainment of America, Buena Vista Games, THQ, and Fiat to name just a few.

To see more of Scott Robertson's personal and professional work, please visit **www.drawthrough.com** and his blog at **www.drawthrough.blogspot.com**

Scott can also be followed online at:
Facebook: www.facebook.com/scott.robertson.005 **Twitter: @scoro5**
Instagram: @scoro5 contact email: **scott@drawthrough.com**

OTHER TITLES FROM SCOTT ROBERTSON

HOW TO DRAW
Paperback ISBN 978-1-93349-273-5
Hardcover ISBN 978-1-93349-275-9

HOW TO RENDER
Paperback ISBN 978-1-93349-296-4
Hardcover ISBN 978-1-93349-283-4

SRW SKETCH COLLECTION 01
Paperback ISBN 978-1-62465-050-5

SCOTT ROBERTSON DESIGN: YOUTUBE CHANNEL

A great FREE educational resource is Scott's YouTube channel, www.youtube.com/user/scottrobertsondesign

Find plenty of educational tutorials related to drawing, rendering and design. New videos are posted almost every Friday.

SCOTT ROBERTSON DESIGN: GUMROAD

www.gumroad.com/scott_robertson

OTHER TITLES FROM DESIGN STUDIO PRESS

THE SKILLFUL HUNTSMAN
Paperback ISBN 978-0-97266-764-7

WOOSH!
Paperback ISBN 978-1-62465-007-9

KALLAMITY: MECH IN INK
Hardcover ISBN 978-1-62465-018-5

INKWORKS: VOL. 1
Hardcover ISBN 978-1-62465-015-4

THE LINE ART CHALLENGE
Paperback ISBN 978-1-62465-035-2

CREATIVE STRATEGIES
Paperback ISBN 978-1-62465-0-260

To order additional copies of this book and to view other books we offer, please visit: www.designstudiopress.com

For volume purchases and resale inquiries, please email: info@designstudiopress.com

To be notified of new releases, special discounts and events, please sign up for the mailing list on our website, join our Facebook fan page, or follow us on Twitter:

 facebook.com/designstudiopress　　 twitter.com/DStudioPress

Published by Design Studio Press
Copyright © 2017 Design Studio Press.
All rights reserved.

Graphic design: Prances Torres

10 9 8 7 6 5 4 3 2 1
Printed in China
First edition, November 2017
ISBN: 978-162465037-6
Library of Congress Control Number: 2017954232